anatomy for artists

a new approach to discovering, learning
and remembering the body

Anthony Apesos
illustrations by Karl Stevens

NORTH LIGHT BOOKS
CINCINNATI, OHIO
www.artistsnetwork.com

About the Illustrator

Karl Stevens's graphic novel *Guilty* is in Harvard's Fogg Art Museum, won a 2004 Xeric Foundation grant for comic self-publishing, and has been translated and published in France and the Netherlands. *Guilty* parodies the hipster paradise of Allston, Massachusetts. Stevens draws a regular strip for the alternative weekly *Boston Phoenix*.

Portrait by Anthony Apesos

Anatomy for Artists: A New Approach to Discovering, Learning and Remembering the Body. Copyright © 2007 by Anthony Apesos and Karl Stevens. Manufactured in China.
Published by North Light Books, an imprint of F+W Publications, Inc., 4700 East Galbraith Road, Cincinnati, Ohio, 45236. (800) 289-0963. First Edition.

Other fine North Light Books are available from your local bookstore, art supply store or direct from the publisher at www.fwbookstore.com.

11 10 09 08 07 5 4 3 2 1

DISTRIBUTED IN CANADA BY FRASER DIRECT
100 Armstrong Avenue
Georgetown, ON, Canada L7G 5S4
Tel: (905) 877-4411

DISTRIBUTED IN THE U.K. AND EUROPE BY DAVID & CHARLES
Brunel House, Newton Abbot, Devon, TQ12 4PU, England
Tel: (+44) 1626 323200, Fax: (+44) 1626 323319
Email: postmaster@davidandcharles.co.uk

DISTRIBUTED IN AUSTRALIA BY CAPRICORN LINK
P.O. Box 704, S. Windsor NSW, 2756 Australia
Tel: (02) 4577-3555

Library of Congress Cataloging in Publication Data
Apesos, Anthony
 Anatomy for artists : a new approach to discovering, learning and remembering the body / by Anthony Apesos ; illustrations by Karl Stevens. -- 1st ed.
 p. cm.
 Includes bibliographical references and index.
 ISBN-13: 978-1-58180-931-2 (pbk. : alk. paper)
 ISBN-10: 1-58180-931-X (pbk. : alk. paper)
 1. Anatomy, Artistic. 2. Human anatomy. I. Stevens, Karl. II. Title.
NC760.A69 2008
743.4'9--dc22
 2007009292

Edited by Amy Jeynes
Production edited by Mona Michael
Designed by Guy Kelly
Production coordinated by Matt Wagner

Metric Conversion Chart

To convert	to	multiply by
Inches	Centimeters	2.54
Centimeters	Inches	0.4
Feet	Centimeters	30.5
Centimeters	Feet	0.03
Yards	Meters	0.9
Meters	Yards	1.1

About the Author

Anthony Apesos is an artist and professor at the Art Institute of Boston at Lesley University. He studied at Vassar College, the Pennsylvania Academy of Fine Arts and received his MFA from the Milton Avery Graduate School of Fine Arts at Bard College. He has exhibited in California and throughout the eastern United States; done major commissions; and been reviewed or published in the *Boston Herald*, the *Boston Globe*, the *Philadelphia Inquirer*, *New Art Examiner* and *San Francisco Art Week*. He has spoken on art techniques, history, figure composition and narrative art.

Portrait by Karl Stevens

Acknowledgments

First I must thank Frank Hyder, who, many years ago, as chair of the painting department at Moore College of Art and Design, offered me a class in introductory anatomy. Without the opportunity to work out my ideas through teaching them, it would never have occurred to me that there was the need for another book on artistic anatomy. Much of my approach was developed through conversations with Professor Leo Steinberg, whose generosity of mind and interest in this project were of greatest inspiration. Kevin Salatino offered invaluable support at every stage of this book's growth. James Apesos, M.D., pointed out some oversimplifications in my manuscript. Tina Newberry's comments on the anatomy of the foot came at a crucial moment when my writing of the text was stalled.

In the actual production of the book, priority of thanks go to my illustrator, Karl Stevens, whose drawings complement and clarify my text. At North Light Books, Amy Jeynes worked as my editor and always made suggestions that led to improvements. Matt Riedsma typed the revisions resulting from these suggestions; his ability to read my handwriting deserves special mention. Also at North Light, the contributions of Mona Michael, Guy Kelly and Matt Wagner are appreciated. My colleague, Geoff Fried, produced out of simple friendship and interest in this project a prototype for the book's design. The Art Institute of Boston at Lesley University gave me a timely release from teaching so this book could be completed. The librarians at Lesley University, especially Raye Yankauskas, were always helpful in fulfilling my many interlibrary loan requests relevant to this and other projects. Karl joins me in acknowledging our debt to the many models who posed for the illustrations. Their contributions cannot be overstated, especially that of David Chick.

Twenty years of conversations with Carolyn Smyth were the essential locus of the development of my point of view as an artist; to her words are insufficient, but gratitude, I hope, understood. Finally, my wife, Natasha Seaman, was my constant companion throughout the writing, and beside reading, critiquing, typing and editing, she encouraged every word. It is to her and to our daughter, Helen, that I dedicate this book.

table of contents

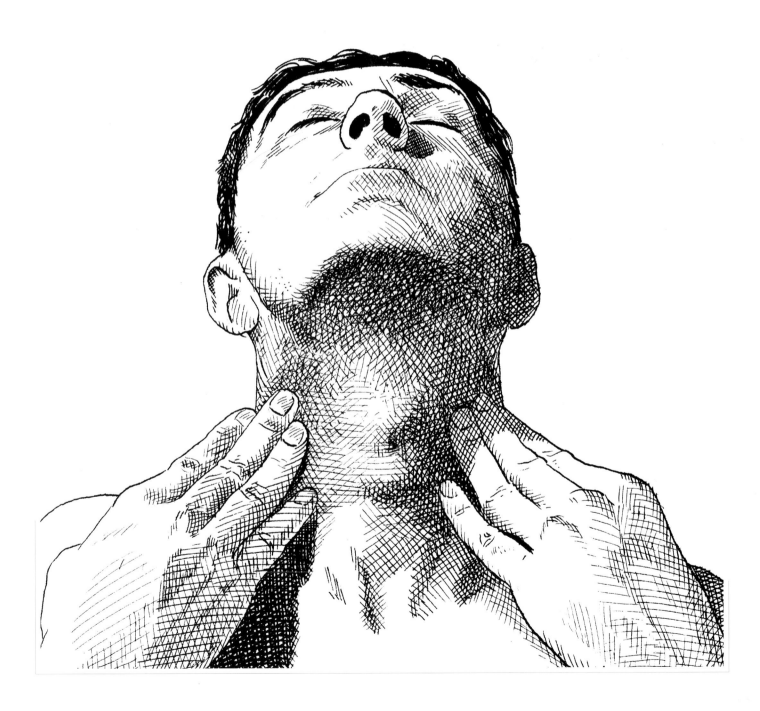

Introduction

If you use the body as a means of expression, whether as a painter or sculptor, or even as a dancer or bodybuilder, a knowledge of the structure and function of the human form is essential. To my knowledge, no other anatomy book explains the body in the way that you will find here. Here, no part of the body will be discussed without demanding that you find and understand that part on your own body. This demand is essential to make what you read here memorable and vital, because it turns your body into a tool for reference. This approach will re-educate your experience of your own body and will thus give you greater grounding for empathy toward the bodies of others. The study of anatomy as it is presented here also makes the body make sense; it reveals the function and evolution of the body's parts, and thus their meaning. Through deeper understanding, the marks that the artist uses to draw the figure, or the movements with which the dancer expresses feelings, reflect the presence of an enriched mind.

Most academies of art today teach figure drawing with a purely perceptual approach. This is quite straightforward: simply explain to the students how to measure intervals, find directions of lines, and work with a scale of relative light and dark values. The concepts are simple, but their application is difficult. If the drawings are flat and dead, which is likely, it is suggested that the student "loosen up," "work bigger," "use the whole arm." And the drawings will get a degree of calligraphic life, but it is a life that has little to do with the life of the human body that is posing on the model stand.

If you take up bodybuilding, the trainer will show you a series of exercises that, if done correctly and often, will produce results. But the only way to do an exercise properly is to know why it works, and this requires knowledge of anatomy. Evaluating the effectiveness of a new exercise or the usefulness of an unfamiliar piece of equipment is impossible without knowing how the body's structures work.

Understanding, unfortunately, is more difficult to impart than "the basic perceptual principles of drawing" or the mechanical performance of an exercise. It is more difficult, first, because it requires that the teacher possess knowledge; second, because it requires that the teacher has the communication skills to impart it; and third, because students must believe that it is worth their effort to gain it.

For the dancer and choreographer, the benefits of anatomy are especially interesting. In dance, the body is the medium of expression. The movement through space is of obvious importance, but so is the disposition of limbs. The limbs, the trunk, the head, are the vocabulary of dance, and movement is its grammar. To use this vocabulary expressively, one must know the meaning of the "words"; in terms of the body, this means understanding the function of its parts. It is this understanding, not mere athleticism of movement, that marks great choreography. The same knowledge and understanding, not mere perceptual accuracy, are visible in great figurative art.

The essential difficulty of really understanding the body is illustrated by an example from the visual arts. Any art teacher will be familiar with what I call "the snowman effect." If asked where the head is, the beginning artist would reply "on top of the neck," balanced over the torso like a snowman's head placed over the larger snowball beneath it. The problem with this reply is the result it yields in drawing. Almost all beginning art students depicting a standing figure will place the head in a rigidly erect posture directly over the shoulders, giving the usually slouching figure of the typical art school model the posture of a military cadet. The student's beliefs about the position of the head are powerful enough to keep him from correctly depicting what he actually sees, but not so strong that the resulting drawing does not still seem wrong. When queried, although the student can see something is amiss, he cannot

find the mistake and will often rebel if the true nature of the error is pointed out.

The problem is that the experience of our own bodies is more persuasive than the evidence of our eyes. This experience of one's body, or somatic experience, must be re-informed so it corroborates perception instead of confounding it. This book will encourage you to refer constantly to your own body to feel and see how it functions. This is the most direct route to remaking your somatic experience.

This book is an introduction to anatomy; as such it is meant to be read from beginning to end. I often simplify muscle groups by function—this is because i want you to get a complete overview; more precise and detailed information can and should come later. Functional groupings are the essential starting point. As an introduction, this book is meant to facilitate further study. There are many other books on anatomy, some of which are discussed in the bibliography on page 124. The best of these books are excellent for reference. This book is not a reference; rather, it is for reading through from one end to the other.

I have organized the chapters according to the history of our evolution from lower primates. This will explain many particulars of the human form and will also help you understand the body in terms of a narrative, a story that develops over a span of time. This narrative of the body's evolution will make the anatomical information more memorable. Also, just as knowing a word's origin helps us understand its meaning, so evolutionary theory helps us understand the meaning of the parts of our bodies. An evolutionary understanding of anatomy will also give you insight into the uniqueness of the human body and in so doing will deepen your appreciation of the body.

After we review some basic scientific principles, the chapters will follow a pattern that includes reflections on the nature and evolu-

tion of the body part in question, then descriptions of the bones and muscles and tendons of that body part, with frequent instruction for how to find these in your own body. The result will be a reformed and informed knowledge of the body that will give your efforts, whether you are a painter or sculptor, a dancer, choreographer or bodybuilder, a new depth of significance.

Basic Science

To enrich and deepen your understanding of the human figure, you must go beyond familiarity with the bones, muscles, fat and tendons whose contours are visible through the skin. You also should get to know the substance of these tissues, how they function in support and movement, and how they evolved into the very particular forms that we see in the human body.

Substance

The building blocks of all living organisms are cells, which exist in a variety of forms. In complex organisms like ourselves, cells of the same kind assemble into larger masses called tissues. This is so they can work together to aid in the survival of the organism. I believe that it is very useful to see and feel these tissues and to discover how they are bound together firsthand. Toward this end many artists have practiced dissection of human beings, which is the most direct experience with human tissues that the aspiring anatomist can find. But human dissection is not practical for most, certainly distasteful for many, and fortunately not necessary for any. The ancient Greeks did not dissect, and the verity of their depiction of the human body proves that no one needs to.

However, Greek artists had the benefit of witnessing athletics—a prominent part of Greek culture—which were practiced in the nude. Therefore, they could see bodies in all positions of exertion, positions which revealed the location, function and formation of the muscles better than any probing at an embalmed and emaciated cadaver could. Since athletics were practiced by most males in Greek society, the artist not only saw the muscles in strenuous motion,

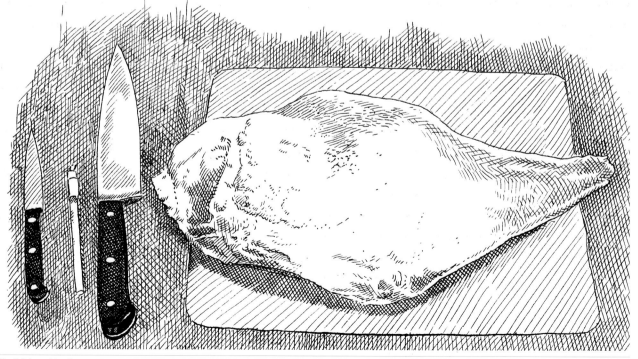

Fig. 1.1. Leg of Lamb

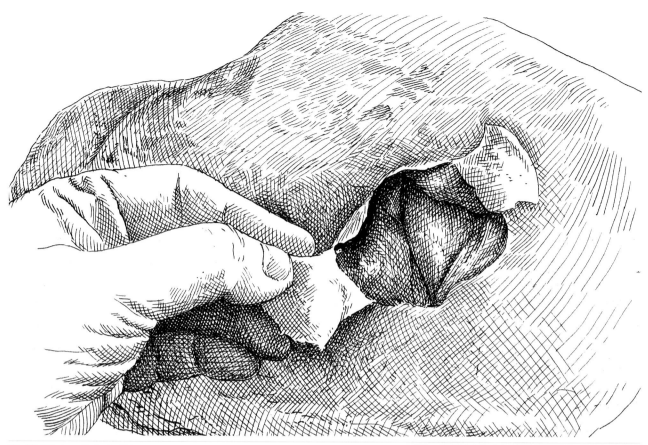

Fig. 1.2. Fatty Layer Under the Skin

but felt them in their own bodies themselves. In the next chapter I will start describing in detail how to learn anatomy from your own body; this, though, will be a less strenuous and more direct method of understanding than the physical gymnastics of the Greeks. If you have access to a workout room with weight machines that exercise different muscle groups independently, you can augment the lessons in this book with unforgettable clarity.

But although the Greeks showed us that we needn't dissect the human body to understand anatomy, we still should know the nature of the body's tissues through direct familiarity. The easiest way to do this is with some help from the butcher shop: a full leg of lamb will not show you much about the exact structure of your own leg, but it will show you all you need to know about what muscle, bone, cartilage, and other tissues look like and how they fit together. The sidebar below contains the ingredients for roasted, boned leg of lamb (recipe on page 14)—after all, if you get a leg of lamb and dissect it, it would be foolish to waste it. In the process of removing the bone, you'll become familiar with all the tissues that you'll need to know about. If you happen to be a vegetarian, the description of the tissues included in this recipe will have to do.

Unwrap the leg of its packaging and you'll see that it is mostly covered with a creamy white substance, the subcutaneous (literally, "beneath the skin") fat, which serves as a layer of insulation for the animal **(Figure 1.1)**. It, like all fat, can be converted into energy when food supplies are low. Scrape off a small bit of the fat and try to spread it on the cutting board **(Figure 1.2)**. Notice how it offers little resistance. That is because fat tissue consists of soft globular cells that are filled with fat. This softness makes fatty tissues useful as cushioning in some parts of the body, especially around the joints.

Roast Dissected Leg of Lamb Ingredients:	Full leg of lamb Butcher knife Small knives Cutting board Meat thermometer	Salt Olive oil, vinegar Pepper, soy sauce Garlic Rosemary

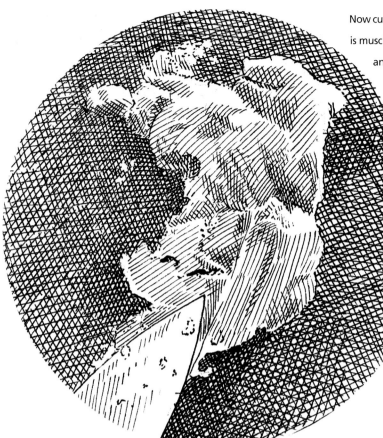

Now cut into the fat until you reach the red meat **(Figure 1.3)**. This is muscle. Take the small knife and pry between the layer of fat and the layer of muscle. Where you've removed the fat from the muscle, you should see a smooth, glossy, transparent bluish surface covering the muscle **(Figure 1.4)**. This is the muscle sheath. It is composed of tough connective tissue and it serves as a support on the outside of each muscle, helping it keep its shape and reducing friction between muscles. It is very strong despite its thinness because it is made of crisscrossing fibrous cells that themselves are largely composed of fibers of collagen. Collagen is a tough elastic made from crisscrossed protein chains; it is rather like plastic. Within this sheath is the muscle. The redness of the muscle is from the many blood vessels that nourish it for the work of strenuous

Fig. 1.3. Fat

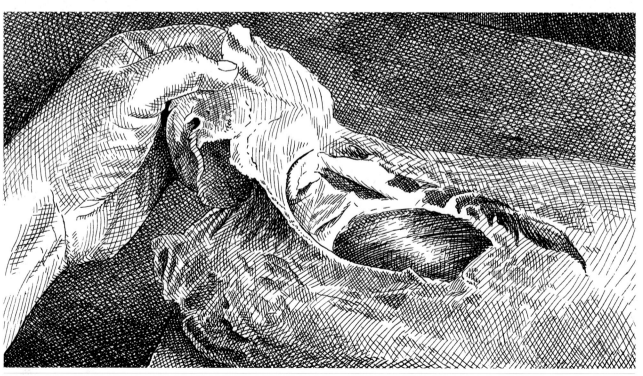

Fig. 1.4. Muscle Sheath

movement. The blood also removes the wastes that are the by-product of the processing of nourishment into energy. During vigorous exercise, the muscles are in such great need of the benefits of blood that they become engorged with it and will actually swell. You can see this in your own arms after a strenuous workout.

Cut into the muscle and look at it closely, and you'll see that it is composed of parallel fibers. All movement in the body is accomplished through the contraction of muscle fibers like these **(Figure 1.5)**.[8] Each of these fibers are themselves made up of muscle cells, which contain interlocking units that slide together when stimulated by nerve impulses. This microscopic contraction within each cell, when it happens in unison with neighboring cells, causes the muscle to contract.

Continue cutting deeper and you will find another muscle separated from the first by another sheath **(Figure 1.6)**. Notice that the fibers of this muscle run in a different direction—that is because this muscle is responsible for a different motion from the first.

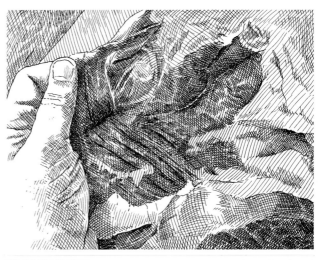
Fig. 1.5. Muscle Fibers

I stress all, although there is in fact one major exception: the penis, which is erectile tissue and enlarges and straightens not by muscular contraction but by being filled with blood.

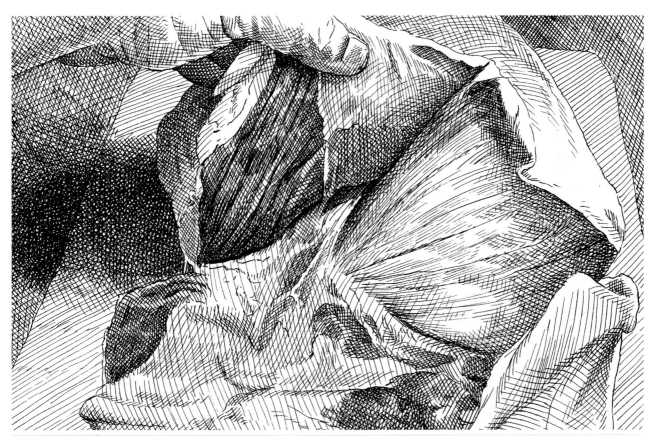
Fig. 1.6. Deep Muscle

Keep cutting until you reach the bone. Notice how the length of the muscle is related to the length of the bone (**Figure 1.7**). With the large or small knife, whichever feels more comfortable, begin cutting under the bone along its length to free it from the surrounding muscle. Continue cutting in both directions, up and down the bone. At the larger end you will find where the leg bone meets

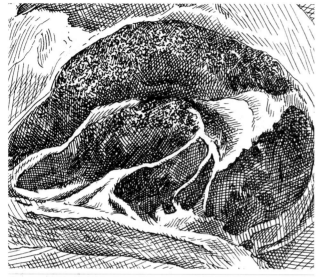

Fig. 1.7. Cross Section of Muscle

the pelvis. Keep cutting until you free the joint of the leg and the pelvis. Wedge your small knife into the space where the two bones articulate, or come together in the joint, and pry them apart. You will reveal the ball of the leg bone and how it fits into the socket of the pelvis (**Figure 1.8**). Then you will see a cord that connects them. This is a ligament—the connective tissue that holds bone to bone. Both the ball and socket are covered with a blue-white tissue that is hard, wet, and amazingly smooth to the touch. This is cartilage, there to cushion the two bones and to provide a nearly friction-free surface for them to slide over each other. When you're done at this end, continue to cut the bone out down toward the lower leg.

Here you will find another joint, the knee. Before you cut all the muscle away from the bone, look closely at how the muscles taper where they attach to this joint. Notice also that as they taper, they become more fibrous, until they are only cords of fiber. These cords are tendons, the tissues that connect the muscle to bone, composed of collagen fibers similar to those that make up the sheath of the muscles. Instead of crisscrossing here, they are parallel for maximum tensile

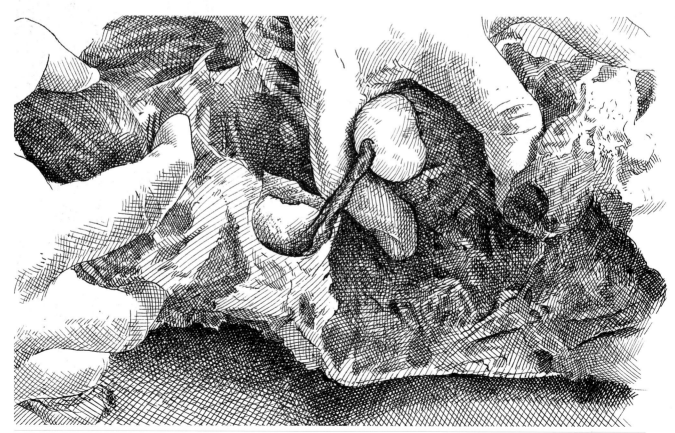

Fig. 1.8. Hip Joint: Cartilage and Ligament

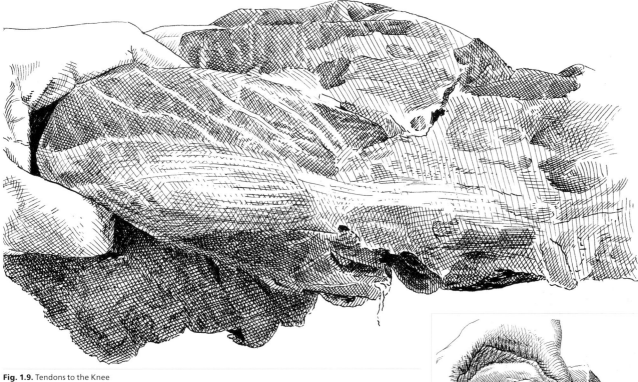

Fig. 1.9. Tendons to the Knee

strength. If you look closely at the tendon, you'll see it resembles filament tape **(Figure 1.9)**.

Cut these tendons from the bone and work your small knife between the bones of the joint. There you'll find the cartilage of the joint and ligament that links the two bones together **(Figure 1.10)**.

Continue to work the bone out of the flesh. When you've finally removed it, place the bone on the cutting board and chop into it with your large knife. As the illustration shows, a hammer will help you do this with more precision **(Figure 1.11)**. Be careful—a blow that can sever a leg bone can easily sever a finger. Look at the inside of the bone and you'll see that

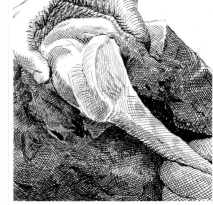

Fig. 1.10. Cartilage of Knee Joint

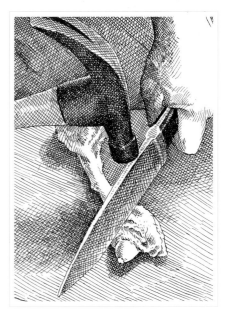

Fig. 1.11. Cutting the Bone

bone, too, is a living tissue. The bones not only make up the skeleton which supports the body, but also they house the marrow which is essential for the manufacture of red blood cells **(Figure 1.12)**.

You now have real familiarity with all of the tissues to which we will refer throughout our discussion of anatomy.

Now heavily salt the entire boneless piece of meat—rubbing the salt into the flesh and then rinsing it off thoroughly. This will help disinfect the meat that you've been handling and are now ready to prepare for cooking. Place the meat in a roasting pan and generously slather it with oil, vinegar, soy sauce, crushed or dry garlic, rosemary, and pepper. Let it marinate for an hour at room temperature. Preheat the oven to 500°F (260°C). This high temperature will sear the juices in. Place the lamb in the oven; immediately lower the heat to 300°F (149°C) and cook until it reaches an internal temperature of 170°F (77°C) (be sure the meat thermometer is inserted in the thickest part of the roast), or for about 30 minutes per pound. When you eat this lamb, you'll know, perhaps for the first time, what you're eating.

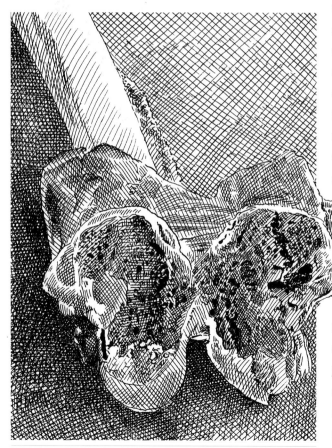

Fig. 1.12. Bone Marrow

14

Function

All of the aforementioned tissues—fat, muscle, cartilage, tendons, and ligaments—work together to support, protect, and move the body. Bone, of course, is primarily for protection and support. Muscle moves the bones through contraction; ligament holds the skeleton together; tendon links the muscle to bone; cartilage provides cushioning and flexibility; and fat cushions, insulates, and acts as an emergency energy store.

The skeleton provides light and strong support. Bone can be in long strong columns, as in the limbs; short compact blocks, as in the spinal column; or flat plates, as in the skull, ribs, or pelvis. Some bones are fused together to form unmovable units, as in the skull; others are united with cartilage to provide limited flexibility, as in the rib cage; and others are jointed together via ligaments for maximum movement. Of these last joints, there are two primary kinds: hinge joints, which allow movement in two directions—the elbow, for example, which extends or bends; and ball-and-socket joints, which rotate in all directions—the hip, for example, which moves with great freedom **(Figure 1.13)**.

The movement of these joints is affected by muscles. It is essential never to forget that the skeleton is moved only by the contraction and relaxation of muscles. Muscles can relax but they don't actively expand; they can't push the bones but can only pull them. For this reason, muscles occur in pairs called antagonists **(Figure 1.14)**. Muscular antagonists work as opposing forces in moving the bones: the two primary motions that happen at a joint are extension, which is when the bones of a joint are straight in relation to each other, and flexion, when the joint is bent. For either of these two actions to occur, one of the antagonists must relax and the other must contract. If both are relaxed, the joint is limp; if both are contracted the joint is rigid. In either case, movement does not occur.

Explore your body and you will see that the joints of the bones are free of muscle bulk—bulk which would get in the way of movement. Instead, the muscles are grouped between the joints, along the length of bones, and then taper into the thin but strong tendons that cross over the joints to connect to other bones. This paucity of flesh at the joints reveals a good deal of bony structure of the joints which can be seen and even more clearly felt. These and other bones just beneath the skin are called subcutaneous. We will have constant reference to the subcutaneous bones in what follows; they are essential land-

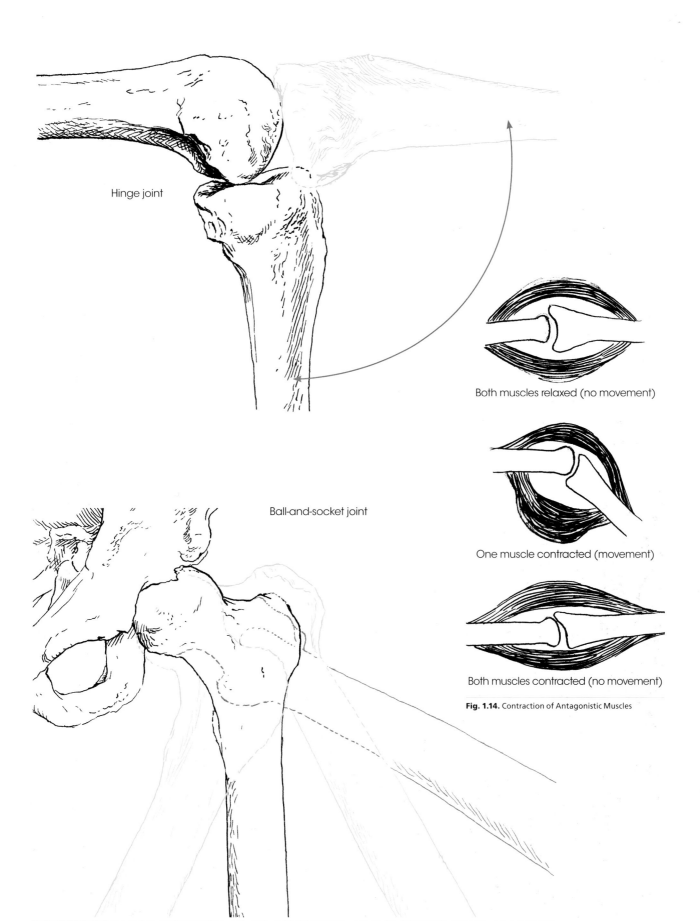

Hinge joint

Ball-and-socket joint

Both muscles relaxed (no movement)

One muscle contracted (movement)

Both muscles contracted (no movement)

Fig. 1.14. Contraction of Antagonistic Muscles

Fig. 1.13. The Two Kinds of Movable Joints

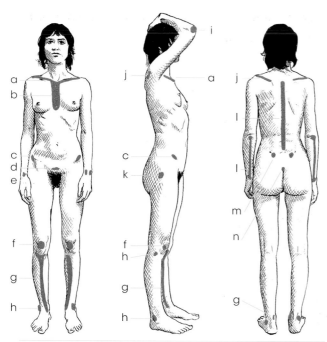

Fig. 1.15. Thin Figure

a	Clavicle	f	Patella	k	Great trocanter
b	Sternum	g	Tibia	l	Backbone
c	Iliac crest, front	h	Fibula	m	Iliac crest, back
d	Pubic arch	i	Ulna	n	Coccyx
e	Radius	j	Spine of the scapula		

Fig. 1.16. Full Figure

marks which vary little from person to person. On a very thin person they appear as bumps **(Figure 1.15)**, and on an obese or muscular person they appear as dimples or dents **(Figure 1.16)**; either way they are thinly covered by flesh and therefore easy to find.

Evolution

As we saw with our leg of lamb, the basic substance and mechanics of the body differ little among the vertebrates. But our concern here is not with all animals with backbones, but with one unique example: the human animal. How we acquired our particular characteristics is described by evolutionary theory.

The theory of human evolution from the lower primates is a narrative, as much a story as any parable. It is the story of how, beginning from an unspecialized little mammal—the tree shrew—we received over time a series of characteristics that make us human. The episodes of this story according to most paleo-anthropologists are shown in **Figure 1.17**.

The story of the evolution of our species is helpful to consider when studying anatomy because it arranges the acquisition of the characteristics of our body in a linear and causal narrative. According to modern evolutionary theory, hands with opposable thumbs were the first characteristic to develop that is specific to the higher primates. Hands came about as an adaptation to life in the trees to better grasp small branches and, thus, to climb higher. Next, in order to swing more effectively from limb to limb, the shoulder with its great mobility developed. After perfecting a tree-dwelling existence, our ancestors, for reasons unknown, became terrestrial, bipedal, and erect in posture,[®] all of which required the particular structure of our feet, legs, pelvis, and spinal column. With our hands freed from locomotion, we could put them to work at other tasks, like gathering, carrying, and toolmaking. Once we discovered toolmaking, creative intelligence for the first time became of the highest value for our survival, and, consequently, our brains developed. This story of evolutionary change guides the sequence of the ensuing chapters of this book.

Whether or not the reader believes the story of evolution as told here, to me it offers some explanation of why we are built as we are. We need an explanation as artistic[®] anatomists; an explanation provides a sense of history and significance to each body part, a paradigm for comprehension. I do not offer this explanation as the truth (though I believe it to be so) but more as a "just-so story," like

the one Kipling tells of how the elephant got its trunk. Whether true or not, it can affect our sense of the body's meaning and, thus, how we use it for expressive ends.

In this sense, the scientific theory of evolution is used here as a myth giving coherence to what otherwise could be a random assortment of attributes. Myths have always served artists in developing their attitude toward how and what they depict, yet today is an age with no universally believed traditional mythology. Perhaps the theory of evolution can serve this function.

There is a lot of speculation on this; one interesting and convincing theory is to be found in Donald Johanson and Maitland Edey, *Lucy: The Beginnings of Humankind,* chapter 16, "Is It a Matter of Sex?" New York: Warner Books, 1982.

Here and in the pages that follow, *artistic* is meant to refer to all pursuits that use the body for aesthetic or expressive ends, e.g., painters, sculptors, dancers and bodybuilders.

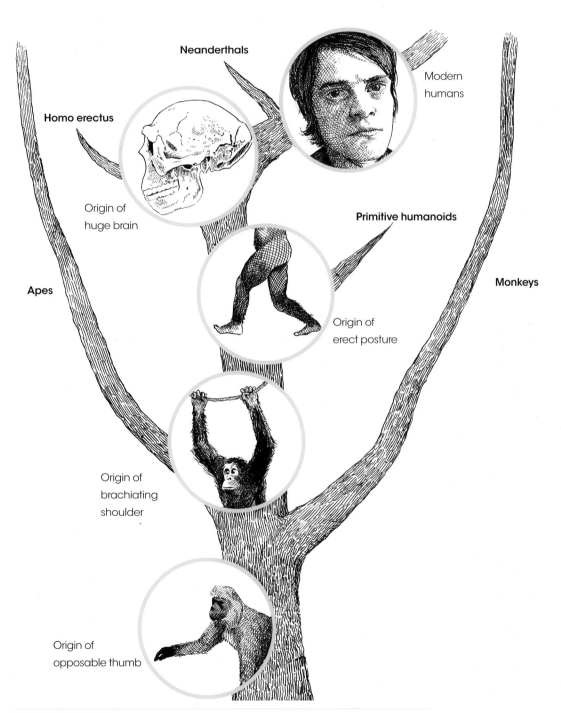

Fig. 1.17. Human Evolution

CHAPTER TWO
The Hand

We begin our study of the parts of the body with the hand because, in human evolution, the hand came first. As tree-dwelling animals, our primate ancestors developed four extremities that terminated in grasping appendages. The hands are these appendages as they still exist in our upper extremities. What we can accomplish is done primarily by the hands—and if the hands can't do it unaided, they can fashion tools that can.

The features that allowed grasping of branches in climbing—the thumb, a digit that can close over the palm, and the fingers, which can bend down toward the wrist—also allowed other functions, such as holding small objects for inspection and for possible preparation for ingestion. This double function of the hands as a means both of climbing and of food preparation is to be found in many arboreal animals. But unlike squirrels or raccoons, monkeys and apes have lost their claws, which gives primates finer manipulation with the fingertips **(Figure 2.1)**. This loss is a disadvantage in climbing, but it is compensated for through greater strength in the hands and feet; instead of digging into the bark of a tree with claws to climb it, apes and monkeys use their strong grip to grasp onto rough surfaces or around branches **(Figure 2.2)**.

Fig. 2.1. Precision Grip

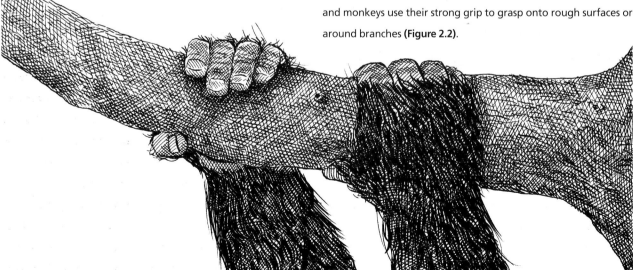

Fig. 2.2. Power Grip

I owe this simple but profound observation to Professor Leo Steinberg; it was the starting point for all of my rethinking about the human body.

Palm of hand

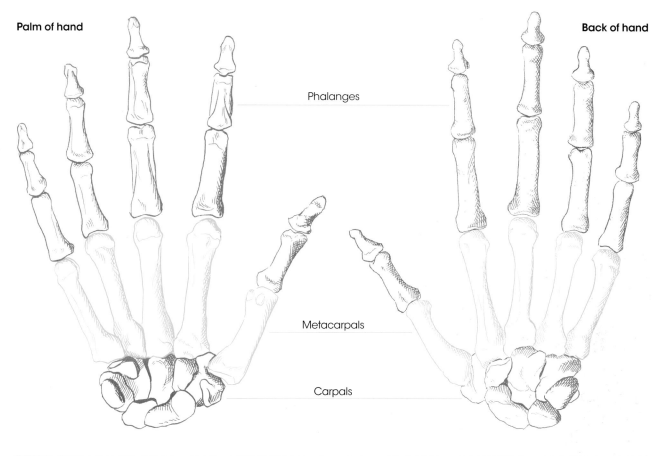

Phalanges

Metacarpals

Carpals

Back of hand

Fig. 2.3. The Bones of the Hand

The hand is thus both a powerful and very delicate instrument that can perform an unlimited number of operations. Consider the variety of the hand's capabilities: punching, slapping, pulling, holding, grasping, squeezing. These are the functions of the entire hand. The digits can also work independently: they can pick, poke, pinch, flick, snatch—together or separately, all with varying degrees of strength or vigor. It is this variety of action that allows the hand to reflect the fullness of the mind's imagining; hands execute the mind's commands and show to the mind in material form what it has conceived. The hands are the primary agents of the mind and as such they not only create but, in all their gestures, reflect the presence of their bearer's spirit.

When beginning students do fast drawings from life, they often omit the hands with the excuse that they are trying to get the gesture and not the details. But almost always the reason for the position of the entire upper body is for the placement of the hands; to leave the hands out is to omit the motive and meaning of the gesture. None of the great figurative artists forgot this, and some indication of the hands is seen in even their quickest sketches.[a] For dancers as well, the placing of the hand is always of great significance either in relation to a partner or in the soloist's gestures.

The hand is a flat, cup-like mass with four parallel cylinders (the fingers) that project from one end, and another shorter and thicker cylinder (the thumb) that projects from the side **(Figure 2.3)**. Opposite the four parallel cylinders, the hand is attached to the thicker

cylinder of the arm **(Figure 2.4)** at the wrist by a hinge joint. This allows the simple flapping motion that we make in waving good-bye. The bones of the arm have bony knobs on either side of the wrist, which limit the extent of motion from side to side. This is one case of many you will discover throughout the body of how the presence of bone always accompanies a limitation of movement and an increase in strength in a joint. There are eight bones of the hand that are closest to the arm, called the carpals. They are closely packed together into a dense, arch-shaped unit; the peak of this arch is on the back of the hand. The advantage of an arch of separate bones is that such an arch can "give" in response to impact. If it were either

not arched or not segmented into separate bones, it would not have the same flexible strength.

Held together through a tight network of ligaments, the arch of the wrist is like a very strong spring that is not easily moved but which will nonetheless bend rather than break. The hollow of the arch is closed by the ligaments that hold it together, forming a tunnel. This tunnel provides protected passage for the major arteries, nerves, and many tendons that pass through to the hand **(Figure 2.5)**. The disadvantage of this tunnel is that its space is limited, which means that if the tendons become overdeveloped, as they can with those who work with their fingers (typists, pianists, guitarists), the

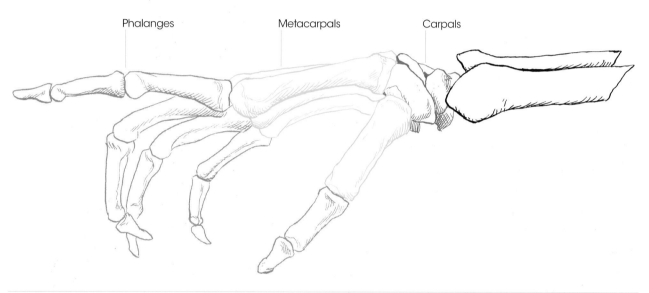

Phalanges Metacarpals Carpals

Fig. 2.4. Side View of Hand

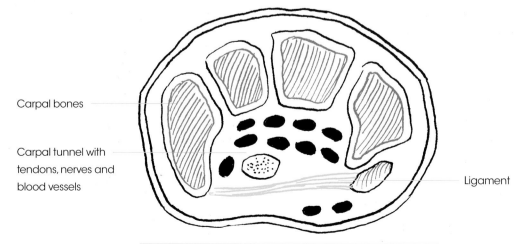

Carpal bones

Carpal tunnel with tendons, nerves and blood vessels

Ligament

Fig. 2.5. Cross Section of Wrist

condition called carpal tunnel syndrome can result, with symptoms of pressure, pain and numbness.

The tendons in the wrist go to the fingers from the muscles of the forearm, which thereby control the movements of the hand. The hand, therefore, is like a marionette—it is moved by the strings (the tendons) and not through a power that resides in the marionette (the hand) itself. The placement of the major muscles that control the hand in the forearm minimizes the bulk of the hand and maximizes its flexibility and delicacy **(Figure 2.6)**.

Attached to the carpal unit in the wrist are the five metacarpals, four of which are parallel and are very limited in movement, and one of which goes off to the side of the hand near the wrist. The latter is the first bone of the thumb and has considerable freedom of movement. The spaces between the four metacarpals of the fingers are filled with the intrametacarpal or intrinsic muscles that control the spreading and pulling together of the fingers: these are among the few muscles used to control the fingers that are found within the body of the hand itself. Each of the metacarpals is slightly curved, contributing to the cup-like shape of the palm. This curvature adds to the hand's grasping ability as well as to the strength of the hand in slapping and punching.

Each of the metacarpals of the four fingers ends in a ball-like surface. This then is received by a shallow cup on the near end of the first bone of each finger; this is a ball-and-socket joint, and it allows for the great mobility of fingers where they articulate to the knuckles. Make a fist and you can see the roundness of the end of the metatarsals on your knuckles. Open your hand and rotate your fingers to see the range of movement this kind of joint allows. This rotation is accomplished by a harmonious succession of contractions and relaxations between the flexors and extensors in the forearm and the intrametacarpal muscles.

Proceeding to the joints that connect the rest of these finger bones, or phalanges, we see a very different joint structure—one designed for greater strength but with more limited movement. This squared-off hinge joint prevents rotational movement, and allows only opening and closing. Each bone of the joint has a groove on the near end and a ridge on the far end, which interlock. If you make a fist again and look at the joints of one of your fingers, you can see the squared-off form of the distal or far end of the phalange as the proximal or near end of the

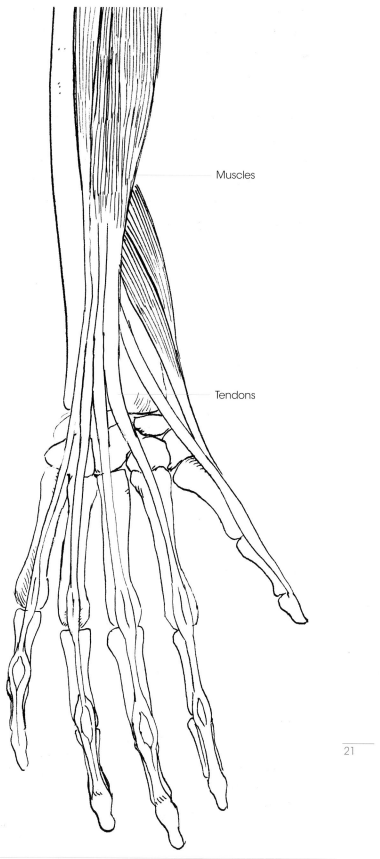

Muscles

Tendons

Fig. 2.6. Forearm Muscles That Control the Hand

next phalange slides behind it **(Figure 2.7)**. The last phalange ends in a flattened disk, the blunt foundation for the cushioning that makes up the fingertips and the bed of the fingernails.

The thumb is like the other fingers except that it has only two phalanges instead of three. Also, instead of having that freedom of movement where its first phalange meets the metacarpals, it has a great range of movement at the junction of the metacarpals to the carpals. Look at this movement on your own hand to see how the thumb revolves at this meeting with the wrist. Contrast this to the limited movements of the joining of the metacarpals of the fingers to the carpals; and compare it to the wide range of movement where the phalanges of the fingers meet their metacarpals.

Now also find on your own body the transitions from the phalanges to the metacarpals, the metacarpals to the carpals, and the carpals to the bones of the lower arm **(Figure 2.8)**. Flatten your hand on a table, palm down, with your thumb toward you, and, feeling slowly down your wrist, note each of these transitions on the back of the hand and feel around to where these transitions can be found on the palm side.

As you do this, you will note that the palm is more padded and less bony than the back of the hand, and that the fingers seem stubbier when viewed from the palm, and longer and more graceful when viewed from the back. This is because the webbing between the fingers extends up the palm almost one-half of the way to the first phalange **(Figure 2.9)**.

The padding on the palm side disguises the powerful tendons responsible for grasping that radiate from the carpal tunnel. This extensive padding is of two kinds: muscle on the bases of both the thumb and pinkie that helps give power to the closing of the thumb over the palm, and fibrous fatty tissue covering the surface of the palm and fingers that protects the hand and increases the effectiveness of the grip. The padded softness of this tissue allows the concave configuration of the palm side of the finger bones to conform closely to grasped objects **(Figure 2.10)**. On the back of the hand this padding is absent and the tendons are thus much more clearly seen. If you stretch your fingers out as far as possible, you will see the tendons fanning out from the

Fig. 2.7. Arrangement of Finger Bones

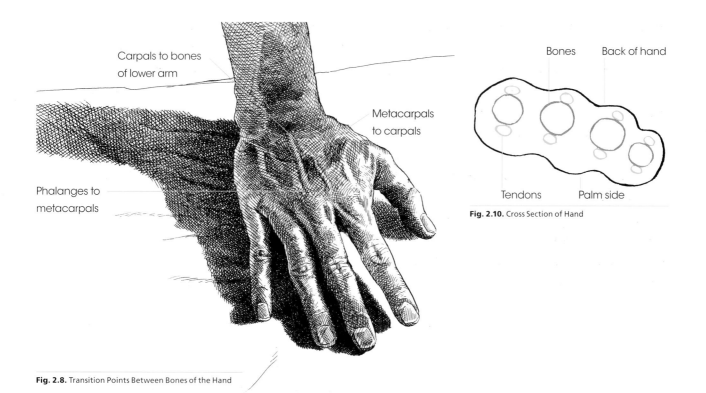

Carpals to bones
of lower arm

Metacarpals
to carpals

Phalanges to
metacarpals

Fig. 2.8. Transition Points Between Bones of the Hand

Bones Back of hand

Tendons Palm side

Fig. 2.10. Cross Section of Hand

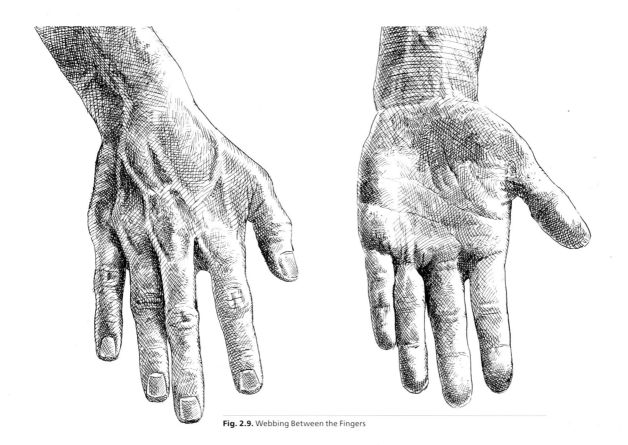

Fig. 2.9. Webbing Between the Fingers

23

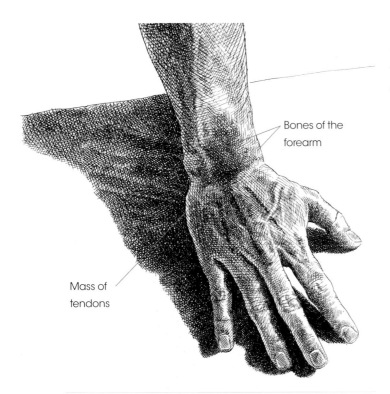

Bones of the
forearm

Mass of
tendons

Fig. 2.11. Find the Tendon and Bones at the Wrist

back of the wrist to the knuckles. Bend your wrist at a sharp angle and feel for three hard lumps at the upper part of the wrist **(Figure 2.11)**. The two on either side are the bones of the forearm; the prominent rise in between is the mass of the tendon before it splits out to the fingers. It may feel as hard as bone, but if you feel it while wiggling your fingers, you will see how it changes shape in movement; bones cannot change shape, only positions. Look very closely at any tendon of the back of the hand and see how it covers the knuckle, and then slowly close your hand into a fist **(Figure 2.12)**. You will observe that the tendon slides off the top of the knuckle to one side, revealing the rounded end of the metacarpal. This sliding off the bone puts the tendon out of harm's way if the fist is used for a punch. You will also see, if you are not very dark-skinned, that the knuckles whiten as they protrude when you make a fist. This is caused by the pressure of the bone against the skin that pushes blood out of the area. This effect is visible in other bony joints like the knees and elbows. The tendons of the back of the hand that continue to the tips of the fingers are not conspicuous—wiggle just the tip of your finger to observe this. The muscles that pull the tendons that control the hand will be discussed in the next chapter.

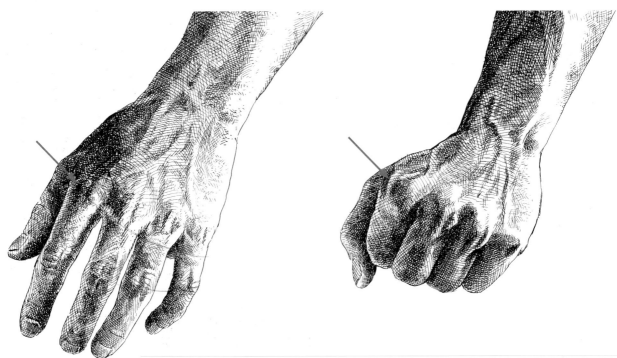

Fig. 2.12. See the Position of Tendons at the Knuckles

The Forearm

The forearm contains the bundles of muscles that control the movements of the hand. These movements are the most complex and articulate in the entire body. The hand can extend (open) and flex (close) as a whole, and each finger can extend and flex separately: each of these movements requires a separate muscle. Also, the hand can rotate. This movement is not generated at the wrist but rather involves the entire forearm. When all of these movements are taken together, at least twenty separate muscles are needed to control the tendons that cause the various movements of the hand.

But these complex movements can be simplified into four separate categories: flexion, extension, supination (turning the palm up), and pronation (turning the palm down). These movements have their source in three major masses of muscle: the flexors, the brachio-radial mass, and the extensors. First, find these three masses on yourself. Put your elbow on the table, turn your palm toward your face and bend your arm so that your fingers rest on your shoulder. A groove in your arm should become easily visible coming from your elbow and going to the wrist bone near the pinkie **(Figure 3.1)**. This groove is the ulnar furrow, so called because it follows the edge of the ulna,

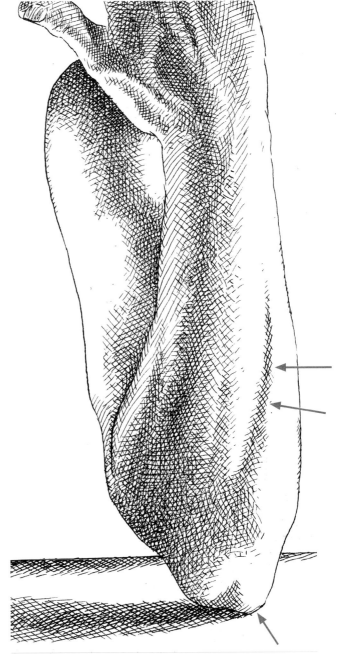

Fig. 3.1. The Ulnar Furrow

25

one of the two parallel bones of the lower arm. If you make a tight fist (it is even more effective if you grip a rubber ball), you will see a group of muscles contract in the arm. These are the flexors, which mass around the arm from the ulnar furrow toward the palm side of the forearm (Figure 3.2). Most of the tendons of the flexors show as the tough stringy cords in the middle of the wrist, which disappear into the carpal tunnel and extend under the padding of the palm. One flexor tendon of great significance to the form of the wrist does not extend to the palm, but is inserted on the pinkie side of the carpals. This tendon is especially obvious if you flex your wrist (Figure 3.3). See how it squares off the form of the forearm here. The contraction of the flexors makes the hand grasp, so it is not surprising that the muscles for this most important function of the hand make up more than half of the musculature of the forearm. To find the other margin of this group, grip your hand, palm up, around a loop of rope or a belt that you've passed under your foot, pressing down with your foot to give maximum resistance. Try to bend your arm to pull the loop upward. In doing this, another muscle mass will be clear, made of two large parallel muscles. For convenience we will call this the brachio-radial mass after the larger of the pair (Figure 3.4). The flexors

Fig. 3.2. Contracting the Flexors

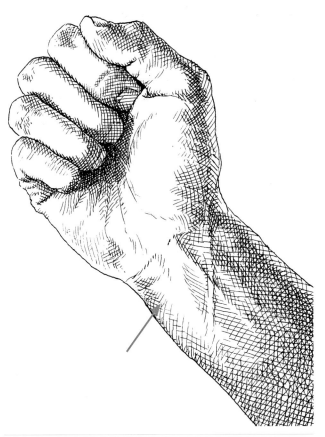

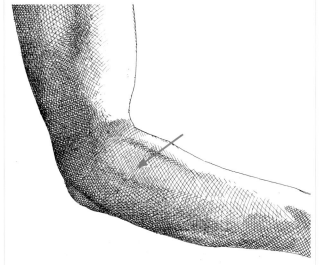

Fig. 3.4. Contracting the Brachio-Radial Mass

Fig. 3.3. The Tendon of Flexion of the Pinkie

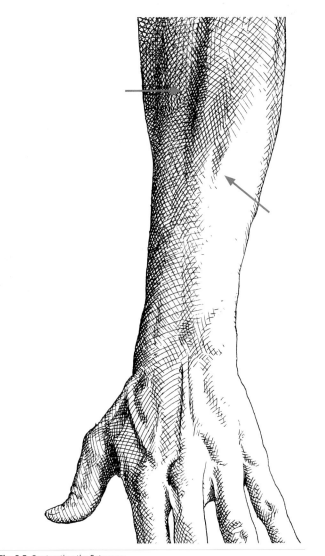

that you found on the inner margin of the ulnar furrow continue around the inner side of the forearm to the inner margin of the brachio-radial mass. Find the outer margin of the brachio-radialis, then, with your palm down, put your fingers under the edge of a table and try to lift and fan them out. This effort of extending the fingers will cause the third muscle mass, the extensors, to contract. Follow them as their tendons fan out from the wrist to the fingers **(Figure 3.5)**. You will find this group spanning from the outer margin of the brachio-radialis, around the outer side of the arm to the ulnar furrow.

Fig. 3.5. Contracting the Extensors

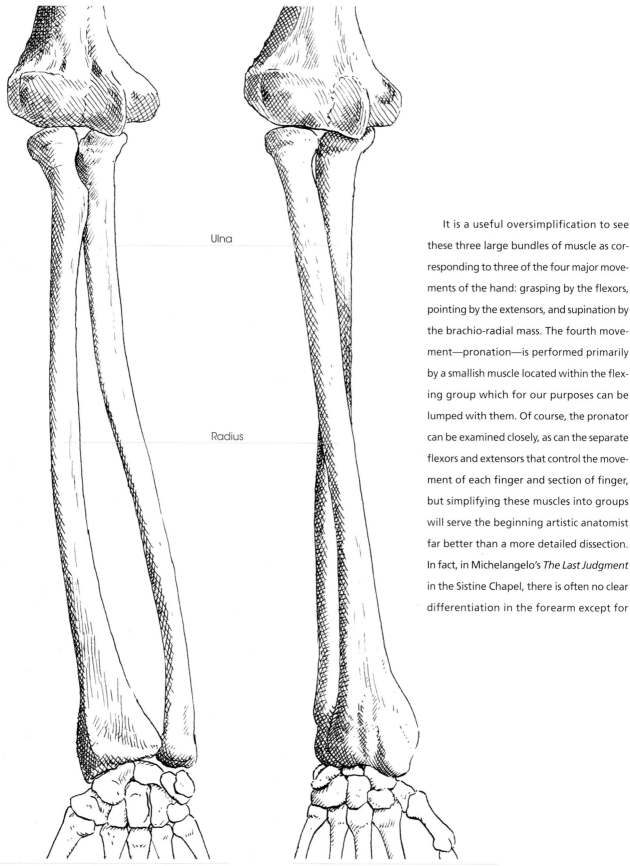

Ulna

Radius

It is a useful oversimplification to see these three large bundles of muscle as corresponding to three of the four major movements of the hand: grasping by the flexors, pointing by the extensors, and supination by the brachio-radial mass. The fourth movement—pronation—is performed primarily by a smallish muscle located within the flexing group which for our purposes can be lumped with them. Of course, the pronator can be examined closely, as can the separate flexors and extensors that control the movement of each finger and section of finger, but simplifying these muscles into groups will serve the beginning artistic anatomist far better than a more detailed dissection. In fact, in Michelangelo's *The Last Judgment* in the Sistine Chapel, there is often no clear differentiation in the forearm except for

Fig. 3.6. Radius and Ulna, Pronated **Fig. 3.7.** Radius and Ulna, Supinated

At wrist

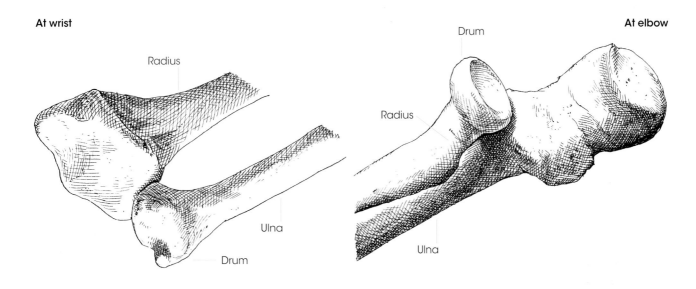

Radius

Ulna

Drum

Drum

At elbow

Radius

Ulna

Fig. 3.8. Radius and Ulna

the division into the three major groups described here. To work on this vast scale, Michelangelo simplified his forms—but what is significant is that he simplified them according to function, not into the meaningless cylinders and boxes so often recommended to beginning artists.

* * *

The two parallel bones of the forearm are beginning to emerge from our exploration **(Figure 3.6)**. We've seen the ulna as a bone of the wrist near the pinkie and revealed up the arm beneath the ulnar furrow, the grooved margin between the flexors and extensors. The other bone of the forearm is clearly visible and palpable only at the wrist near the thumb: it is the radius, so called because its movement in relation to the ulna during pronation (palms down) and supination (palms up) describes a portion of a circle, just as the rotation of the radius of a circle around its center point describes that circle. The radius articulates at the wrist to the carpals, and its movement around

the cylindrical end of the ulna causes the hand to turn in pronation or supination. The ulna remains immobile while the radius turns around it **(Figure 3.7)**.

At the elbow these bones mirror the structure they display at the wrist: the ulna articulates to the upper arm, and the radius terminates in a cylindrical form. The cylinder of the radius turns within the hollow of the ulna that holds it **(Figure 3.8)**. This two-bone system allows for limited rotation to occur both at the wrist and at the elbow. If there were just one bone, movement of the forearm would be restricted to the hinge joints of the wrist and elbow and the rotation would be impossible.

The proximal end of the ulna that articulates to the upper arm is subcutaneous and quite prominent. We can find it if we follow the ulnar furrow up to the elbow. If you bend your arm, you can feel two other bony protuberances nearby. These are the distal knobs, or condyles, of the humerus, the bone of the upper arm. Put one finger on each of these three protuberances of the

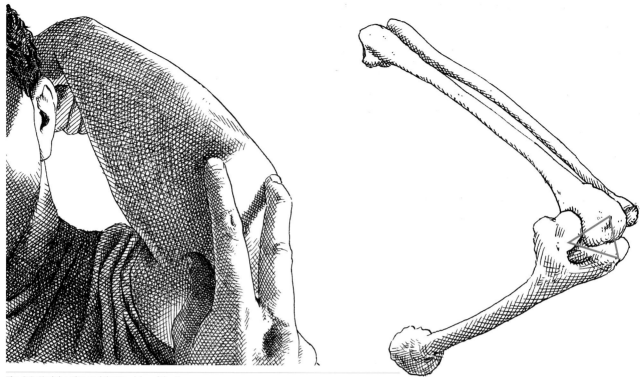

Fig. 3.9. Find the Ulna and the Condyles of the Humerus

elbow and observe how they relate to each other as the arm is flexed and extended. You will observe that the bony knob of the ulna slides right between the condyles of the humerus to form a straight line when the arm is extended. When the arm is bent, the ulna slides out from between the condyles, and the three knobs form a triangle **(Figure 3.9)**. Between the two condyles there is a rather deep depression in the humerus that receives the end of the ulna when the arm is straight. This depression is not revealed when the arm is bent because a powerful tendon from the upper arm is attached to the ulna here and this bridges the gap. The close relationship of the ulna and the humerus is very clear in the skeleton, where we can see that the prominence of the ulna is almost a hook, locking into the groove of the humerus **(Figure 3.10)**. Because men have more massive bones, the depression in the humerus is smaller and the proximal end of the ulna is larger. This means that most men cannot extend their arms into a straight line, while the relatively less massive female skeleton allows the ulna to fit more closely into the humerus. Thus, most women's arms can hyperextend, which is to say bend backwards **(Figure 3.11)**. The interlocking arrangement of the ulna and humerus makes for great osteologic strength when the arm is straight. Osteologic strength is strength that has to do with skeletal structure (osteon is Greek for bone, hence osteologic), as opposed to

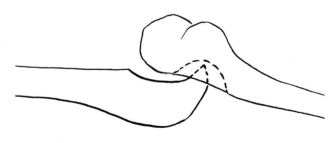

Fig. 3.10. The "Hook" of the Ulna

muscular strength. Osteologic strength requires no energy for it to function—it is simply an aspect of the body's architecture. Its disadvantage is that the very cause of its strength—bone—also restricts movement. The body is arranged in a series of compromises between osteologic strength, which saves energy but restricts movement, and muscular strength, which allows greater motion but uses more energy and takes up more room.

On a small scale, we have already seen these compromises in the difference in the articulation of the joints between the phalanges of the fingers, and the joints between the first phalanges of each finger and their metacarpals. Between the phalanges, the movement occurs at a hinge joint that allows only flexion and extension, while at the knuckle the movement is at a shallow ball-and-socket joint, which allows rotation. As we move up the arm you will see how this variation between reliance on the strength of bone or muscle in the hand parallels the structure of the elbow and the shoulder: the elbow relies more on the bony strength in its hinge joint, while the extraordinarily mobile shoulder relies greatly on muscular strength.

Male

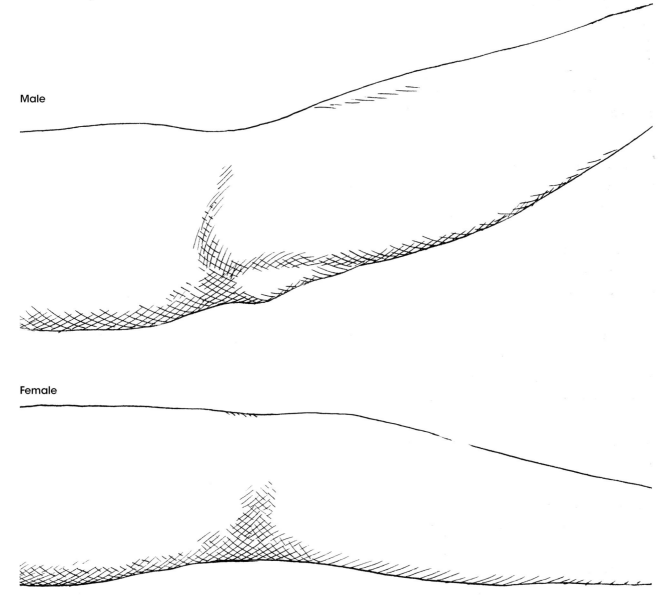

Female

Fig. 3.11. Elbow Extension, Male and Female

The Movement of the Elbow

The two condyles of the humerus, which you found when exploring your elbow in the last chapter (page 29), are subcutaneous; the rest of the humerus is completely covered by the powerful muscles that control the positions of the humerus itself and of the lower arm. To understand the movements of the elbow, we will examine the bones of the shoulder because those bones are where most of

the muscles that bend the arm have their origins. The proximal end of the humerus is rounded and fits into a socket in the scapula (the shoulder blade). This socket is very shallow, which means that there is little bone to prevent freedom of movement in the arm. Immediately next to this socket on the scapula are two major protuberances or processes of bone: the acromion and coracoid processes. These

Front

Back

Side

From above

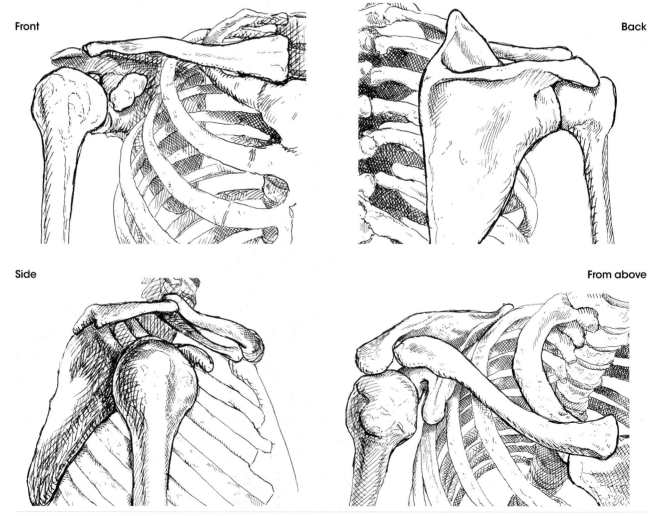

Fig. 4.1. The Shoulder Girdle

32

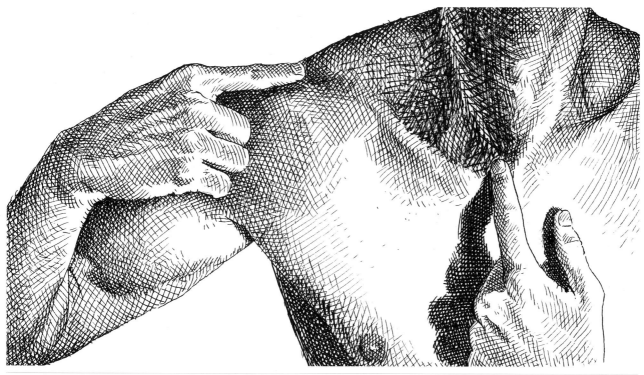

Fig. 4.2. Find the Ends of the Clavicle

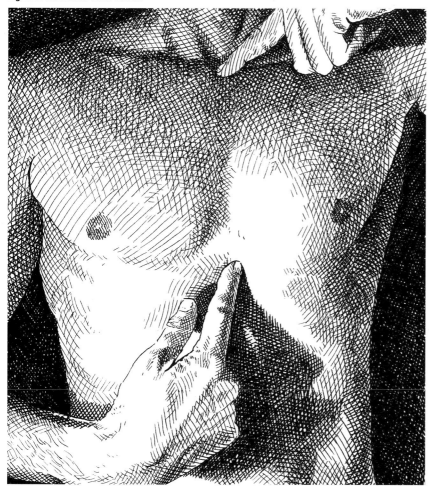

Fig. 4.3. Find the Ends of the Sternum

provide anchors onto which the muscles of the arm and shoulder attach. The acromion is a prominent extension of one of the major landmarks of the back—the spine of the scapula **(Figure 4.1)**.

At the front and top of the shoulder, just touching the outermost end of the acromion, is the clavicle (the collar bone), an elongated S-shaped bone that extends

to the sternum (the breast bone) directly in front and middle of the chest **(Figure 4.2)**.

All of these features are very easy to find on your own body if you begin with the top of the sternum. This feels like a notch about two fingertips wide, right at the top and center of your chest. If you feel straight downward about seven inches, you can find the end of the sternum where the softness of the belly begins **(Figure 4.3)**. Go back to the top of the sternum. Feel the rise of bone on each side of the notch. These rises of bone are the inner ends of the two clavicles. Feel one of the clavicles outward toward the shoulder, noticing the cylindrical form of the bones. Continue along the clavicle until you feel a little drop to a lower level of bone. This lower level is where the acromion process begins **(Figure 4.4)**. Explore this area, moving your finger tips over your shoulder to your back, feeling the flat mass of bone near the shoulder. This is the subcutaneous surface of the acromion; probe along the bone inwards toward the center of your back until the bone ends. This length of bone, including the acromion, is the spine of the scapula **(Figure 4.5)**. Now go back to the front of your chest to just under the outer end of the clavicle. Feel the roundness of the end of the humerus through the muscles that cover it, and then feel slightly inward toward the chest to a slight bump of bone. This is the coracoid pro-cess—most people know when they find this bone because it hurts to press it **(Figure 4.6)**. The coracoid process, although you feel it from the front, is actually a part of the scapula.

You can feel the rest of the scapula if you reach back under your armpit toward your back. There you'll find under the layers of the back muscles a flat wedge of bone. Move your arm around in all directions and you'll feel the scapula move with the motions of the arm. For another view of the scapula reach up your back with your hand toward the shoulder blade. As you do this, the bottom corner of the scapula will rise up and press out against the muscles of the back **(Figure 4.7)**.

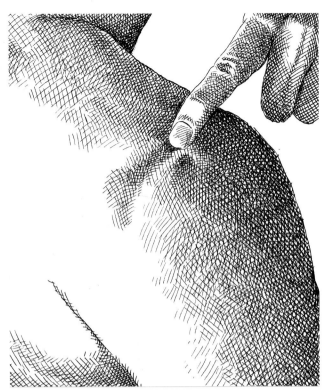

Fig. 4.4. Finding the Acromion Process

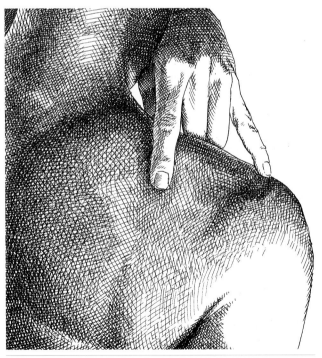

Fig. 4.5. Finding the Spine of the Scapula

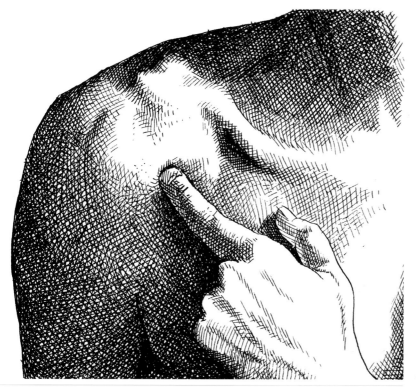

Fig. 4.6. Finding the Coracoid Process

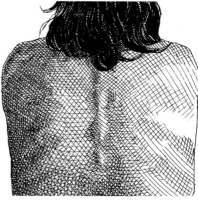

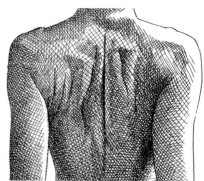

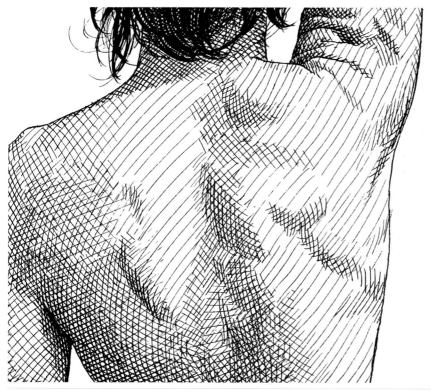

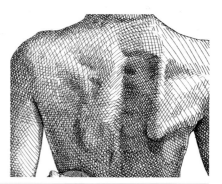

Fig. 4.7. The Movement of the Shoulder Blade

Of course, some bones are attached directly to other bones as in the fixed joints of the skull, but from our point of view in trying to understand the functional movements of the body it makes more sense to consider these fixed joints as structural features of the cranium rather than as divisions between separate bones.

All of these explorations demonstrate the great mobility of the scapula. This mobility has its origin in our tree-dwelling ancestors, who needed it in order to swing from limb to limb. This kind of flexibility is possible because the scapula is attached to the rib cage in an unusual way, through a set of muscles. Most bones are attached to other bones through ligaments.[⊛] Ligament attachments are certainly bendable, but ligament is incapable of the flexibility and elasticity of muscles. Connected in this way to the rib cage, the scapula is free to move over the surface of the rib cage in the directions that these muscles dictate with little interference from bone. But in spite of its movability, the scapula is always easy to find on the nude model because of its prominent spine, which lets us know where and in what position the scapula is. The scapula appears in obese or muscular people as a furrow, but in average individuals it is a slight rise that marks the transition from the back to the shoulder.

The spine of the scapula is nearly perpendicular to the flat wedge of the scapula **(Figure 4.8)**. Above and below the spine are two hollows filled with muscles, which will be examined in the next chapter, that are inserted in the humerus. The circuit of five bones, made up of the two clavicles, the two scapulae and the top of the sternum, nearly encircles the top of the chest, and is called the shoulder girdle.

The major muscle of the back of the arm, the triceps, has three places of origin: one on the scapula near the socket for the humerus, and the other two along the length of the humerus. These muscular masses come together to form the rectangle of the triceps at the middle of the upper arm **(Figure 4.9)**. The fibers of the triceps transform into a very powerful tendon that marks the form of the muscle with a distinctive U-shaped depression **(Figure 4.10)**. This tendon is the one already noted at the end of the last chapter because it is

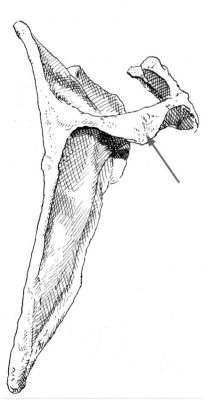

Fig. 4.8. The Spine of the Scapula

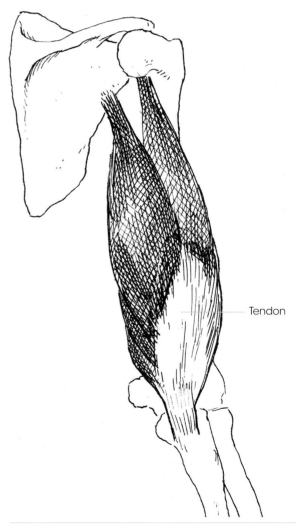

Tendon

Fig. 4.9. Triceps Muscle and Tendon

Fig. 4.10. Tendon of the Triceps

inserted into the ulna between the two condyles. The contraction of the triceps pulls the ulna between the condyles of the humerus, causing the arm to straighten **(Figure 4.11)**. This is the essential movement in the action of pushing away with the arms; it is an excellent example of how muscle action works contrary to intuition: to push away, the arm must extend, but the responsible muscle, the triceps, must contract.

The antagonists of the triceps responsible for bending the elbow joint are a team of three muscles: the brachialis, the biceps and the brachio-radialis, with which you are already familiar. The biceps originates from two locations on the scapula, and is inserted via one tendon into the radius **(Figure 4.12)**. Underlying the biceps is the brachialis, which originates on the humerus and is inserted at the proximal end of the ulna. Together they form the bulk of the front of the upper arm, and are the most significant muscles in bending the arm. In most individuals, the brachialis is rather subtle; most of its surface is covered by the larger and more pronounced biceps. But on very well-developed arms or during great exertion, the brachialis is visible as a separate swelling that peeks out from between the triceps and biceps.

The origin of both these muscles is detectable only in dissection (and will be discussed in Chapter 5), but the insertion of the biceps is easy to find, first with the fingers, and then, when the touch reveals where to look, with the eye. If you place your hand, palm up, under a heavy table and press up as though to lift it, the biceps will noticeably

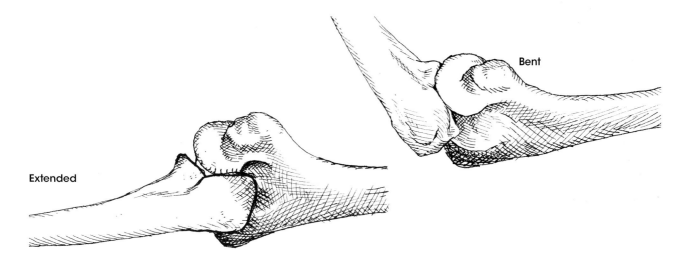

Bent

Extended

Fig. 4.11. Ulna and Humerus

contract **(Figure 4.13)**. Feel the swelling of this muscle along its entire width and length, especially feeling for its edges where it curves under and comes in contact with the other muscles. Now feel down the length of the biceps and notice how the swelling tapers as it approaches the bend in the arms. If the muscles are kept tense, the division between the tapering of the biceps and the fullness of the neighboring brachio-radialis will be clear. Continue down the biceps and the thin tough cord of the tendon will be apparent. Feel across it so that you can discern its cord-like quality. If you feel slightly farther you'll notice a superficial section of this tendon branching off in a diversion away from the brachio-radialis. This usually has little effect on surface form, except in muscular individuals under great physical exertion.

To study the brachio-radialis further, hold a heavy weight in your hand and lift it by bending the elbow. The brachio-radialis will pop up and clearly rise on a clean diagonal up the lower arm **(Figure 4.14)**. Feel the gap between this ridge of muscle and the biceps. If you continue to feel the brachio-radialis up the arm, the line of this diagonal will break and become rounder and steeper as the muscle approaches its origin in the humerus.

The bending and straightening of the arm have been accounted for. In the next chapter we will examine the much more complex and various movements of the shoulder.

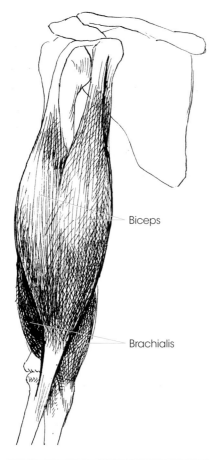

Biceps

Brachialis

Fig. 4.12. Biceps and Brachialis

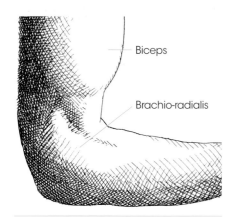

Biceps

Brachio-radialis

Fig. 4.14. Biceps and Brachio-Radialis

Fig. 4.13. Biceps, Contracted

The Movement of the Upper Arm

The ball-and-socket joint of the humerus and scapula allows for a wide range of movement, which can be understood as two pairs of antagonistic movements: raising the arm and lowering it, and moving the arm across the chest and back from the chest. The latter backward movement is the most limited since the presence of the acromion process impedes further movement **(Figures 5.1 and 5.2)**.

The upward movement of the arm is controlled by a large and beautiful muscle—the deltoid, so called because of its shape like the Greek letter delta (Δ) **(Figure 5.3)**. The two deltoids in their origins are broadly rooted along nearly the entire girth of the shoulder. It is important to remember that the deltoid muscle is essential in defining the form of the shoulder on the front, side and back. On the front, the deltoid is attached to the outer one-third of the clavicle. On the side, it is attached to the edge of the acromion process, from which it continues to the back to be rooted on the outer two-thirds of the bottom of the spine of the scapula.

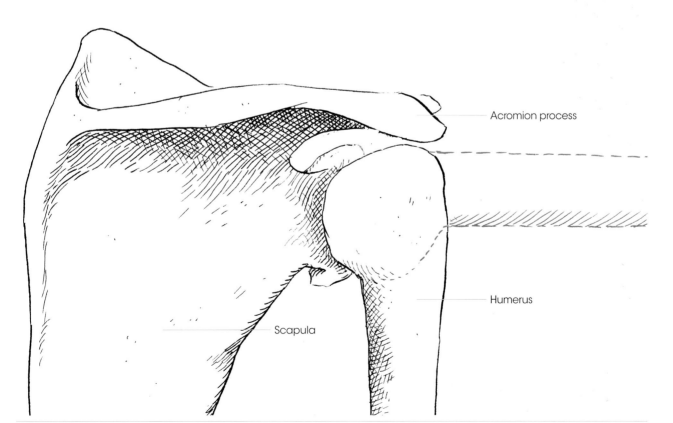

Acromion process

Humerus

Scapula

Fig. 5.1. Movement of the Humerus, Up and Down

39

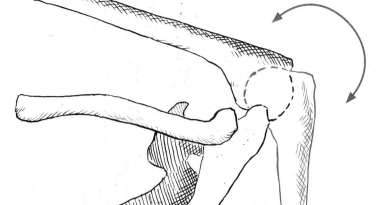

Fig. 5.2. Movement of the Humerus, Front and Back

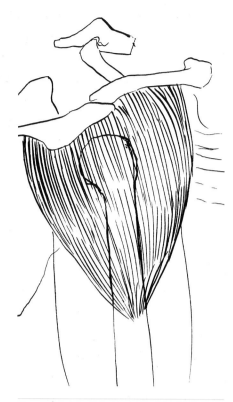

Fig. 5.3. Deltoid Muscle, Side

Front

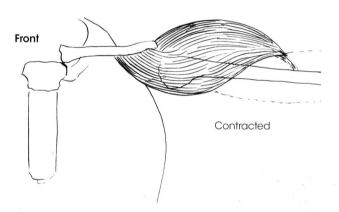

Contracted

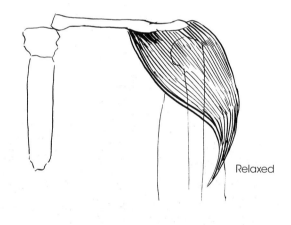

Relaxed

Back

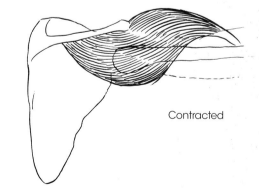

Contracted

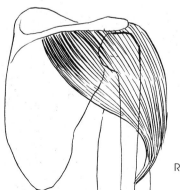

Relaxed

Fig. 5.4. Deltoid Muscle Contracted and Relaxed

From this broad base of origin, the deltoid's fibers converge toward a single tendonous insertion on the outer side of the humerus between the brachialis and the biceps. The action of this muscle is simple to understand: since it is attached to the bones of the shoulder and the outer side of the humerus, contraction of the deltoid will raise the humerus up and out **(Figure 5.4)**.

The borders of the deltoid are easy to find when it is in contraction. If you raise your arm from your side as if it were a wing—especially if holding a weight in the hand—the insertion of the deltoid between the biceps and the brachialis is clear to both sight and touch **(Figure 5.5)**. Following from this point of insertion forward, the deltoid continues until it comes up into the clavicle, leaving a triangular depression bordered by the mass of the deltoid, the clavicle and the upper edge of the pectoral muscle, which we will look at shortly **(Figure 5.6)**.

But first feel the edge of the deltoid as it originates along the lower edge of the clavicle. Feeling along the clavicle away from the neck with your arm still raised, you will feel the

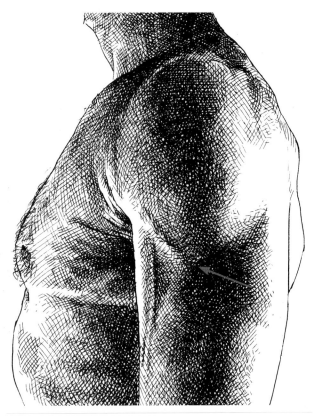

Fig. 5.5. Find the Insertion of the Deltoid

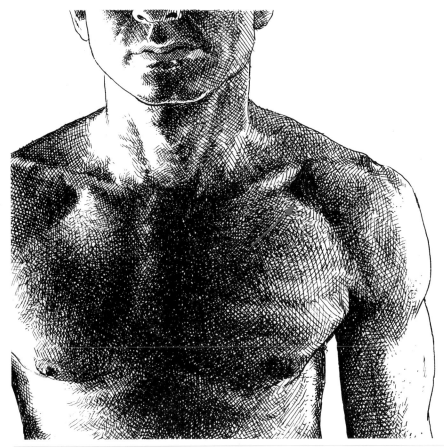

Fig. 5.6. Observe the Space Between Deltoid Muscle, Pectoral Muscle and Clavicle

41

Fig. 5.7. The Depression Between Acromion and Deltoid

very powerful mass of the deltoid in its con-tracted state along the front of the bone. The mass of muscle continues along the edge of the acromion, which, with the arm raised and the deltoid contracted, feels like a hard depression surrounded by the muscle fibers of the deltoid **(Figure 5.7)**. Continue back along the spine of the scapula and feel the deltoid's insertion there. Finally, feel the end of the deltoid at the spine of the scapula, and follow it diagonally down to where it forms the back border of the armpit as it goes to where we began at the insertion into the humerus **(Figure 5.8)**. Repeat all of the above palpations, this time with the arm lowered. In this position, the deltoid is relaxed and the peripher-ies of the muscle will be much less pronounced.

The deltoid is divisible into three parts according to the three locations of its origin: the clavicle, the acromion and the spine of the scapula. Each of these three sections can move independently or in unison. The clavicular section moves the arm up and toward the front, the section attached to the spine of the scapula moves the arm up and towards the back, and the central acromial section in unison with the other two sections moves the arm straight up, away from the rib cage. Because these three sections control different move-ments they can be worked and developed separately.

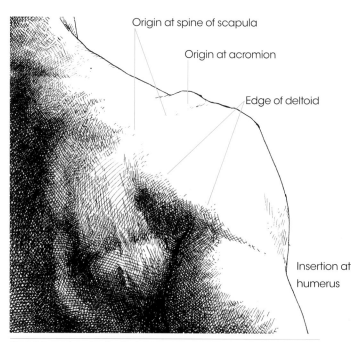

Origin at spine of scapula

Origin at acromion

Edge of deltoid

Insertion at humerus

Fig. 5.8. External Landmarks of Deltoid

Coracoid process

Clavicle

Pectoral

Sternum

Deltoid

Biceps

Fig. 5.9. Structure of Pectoral Muscle

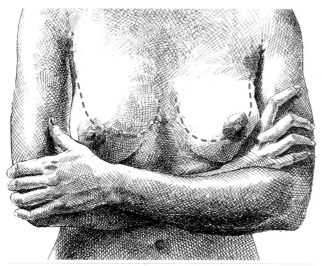

Fig. 5.10. Relation of Breasts to the Pectorals

The pectoral muscle is a major feature of the chest and is responsible for moving the arm across the chest. Its origin is along the inner two-thirds of the clavicle (taking up where the deltoid ends), and down along the outer edge of the sternum. From this broad base it narrows to a thick flat tendon that disappears under the deltoid, where it crosses over the biceps and is inserted onto the outer side of the humerus. The fibers of the pectoral are grouped into bundles, which overlap like the steps of a spiral staircase as they reach toward the insertion under the deltoid **(Figure 5.9)**.

Finding this muscle is easy. Of course, some of its structures are partially obscured in women by the fatty, glandular tissue of the breasts, but the muscle can usually be felt through the breasts, if not always seen. Notice the relation between the covering breast and the outer border of the pectoral **(Figure 5.10)**. This can vary greatly from woman to woman. When you press your palms together, if you are very lean, the overlapping structures of the separate bundles of the muscle will be visible **(Figure 5.11)**. Especially note how the pectoral forms the front side of the armpit before it disappears under the deltoid **(Figure 5.12)**. The contraction of the pectoral muscle causes the arm to move forward and across the chest. It also assists, as we will discuss later, in conjunction with muscles of the back, in pulling the arm down. To feel this structure further, stand in a door frame facing the post with your arm raised and your palm pressing inward on the jamb. Feel the form of the pectoral with the other hand. Be sure to notice the flat long surface of the sternum that is between the right and left pectorals **(Figure 5.13)**.

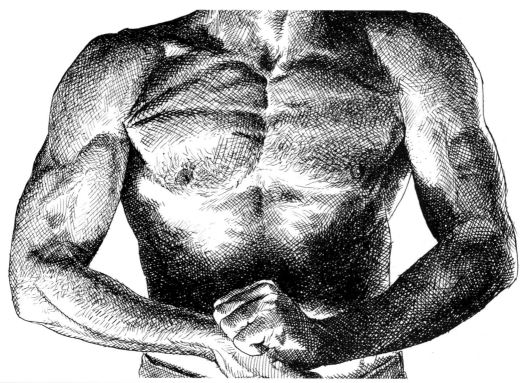

Fig. 5.11. Contraction of the Pectorals

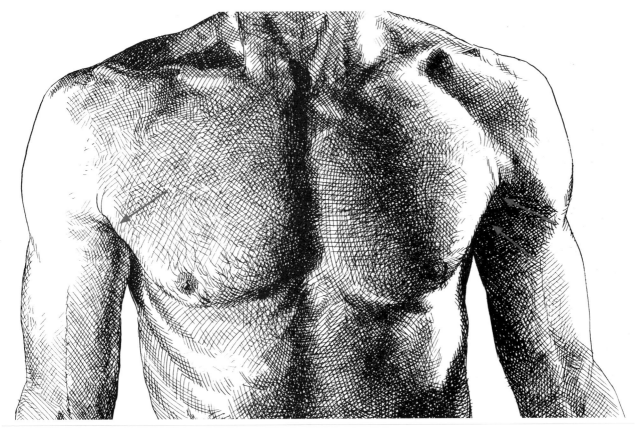

Fig. 5.12. Find the Outer Margin of the Pectorals Near the Armpit

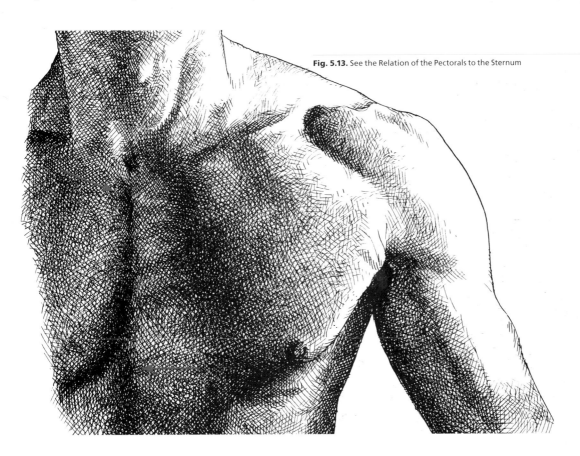

Fig. 5.13. See the Relation of the Pectorals to the Sternum

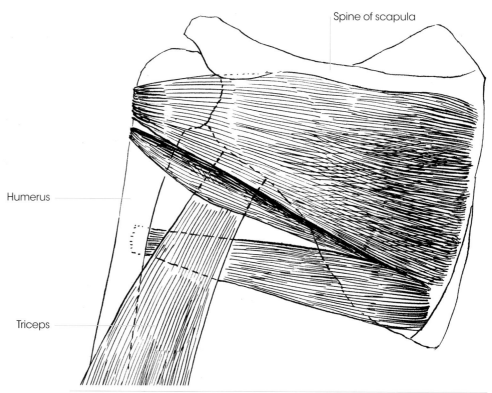

Spine of scapula

Humerus

Triceps

Fig. 5.14. Structure of the Teres Group

Fig. 5.15. Find Borders of the Teres Group

The antagonists of the pectorals are muscles that pull the upper arm toward the back; they find their origin in the two hollows that are formed by the meeting of the flat of the scapula with its spine. We will skip the small muscles in the upper hollow because they are completely covered and only slightly influence surface form. The muscles of the lower hollow, however, are essential to the artistic anatomist: the teres major, the teres minor and the infraspinatus. Here we will consider them together and call them the teres group (**Figure 5.14**). The muscles of this group originate broadly on the scapula, and, like a fan, they narrow into three tendons that are inserted into the top back of the shaft of the humerus. A gap between these tendons allows a space through which part of the triceps can pass so it can attach to the scapula.

To feel the teres group, stand with your back toward a wall and press your elbow back, pushing the wall as hard as possible (**Figure 5.15**). With your free hand, feel the back of your armpit—you will feel the muscles over the scapula swell. Feel this swelling as it becomes the hard tendonous mass of the teres group, which goes under the deltoid into the armpit and inserts into the humerus (**Figure 5.16**).

How the arm is pulled down is the last movement we need

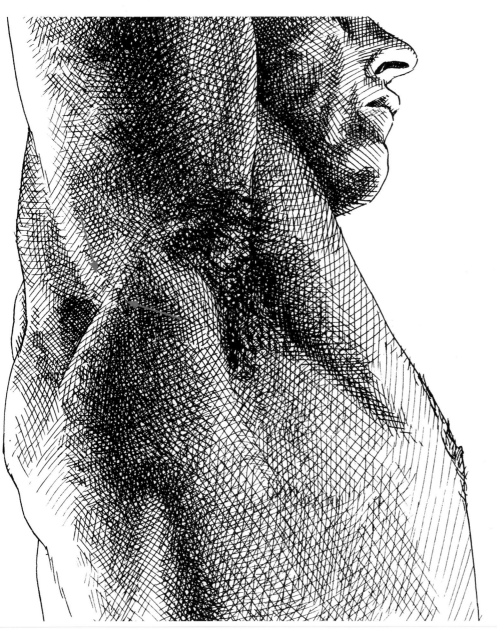

Fig. 5.16. Find the Tendon of the Tenes Group Disappearing Under the Deltoid

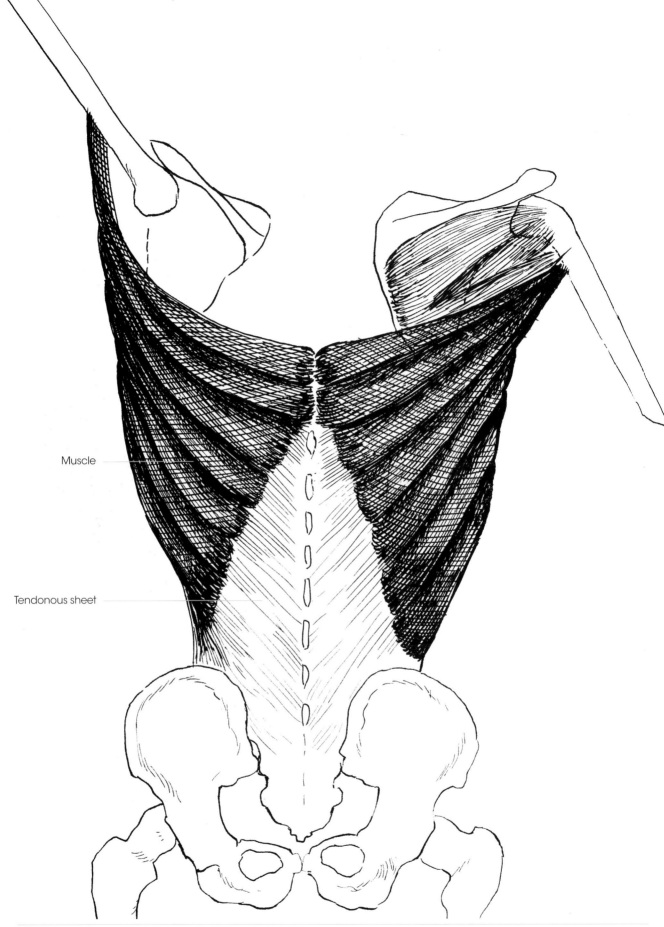

Muscle

Tendonous sheet

Fig. 5.17. Structure of the Latissimus Dorsi, Back

to examine. This action is accomplished through a huge muscle that covers most of the back, the latissimus dorsi **(Figure 5.17)**. It originates along the lower length of the backbone, starting at the middle of the rib cage and continuing down to the pelvis along the backbone to the sacrum and to the side to the iliac crest—we will discuss these bones later in Chapter 10. For now it is sufficient to understand how vast is the extent of the origin of this muscle. From its origins, its fibers reach upwards toward the proximal end of the humerus—gaining strength on the way by twisting around each other to become a tendon that inserts into the humerus near the armpit **(Figure 5.18)**.

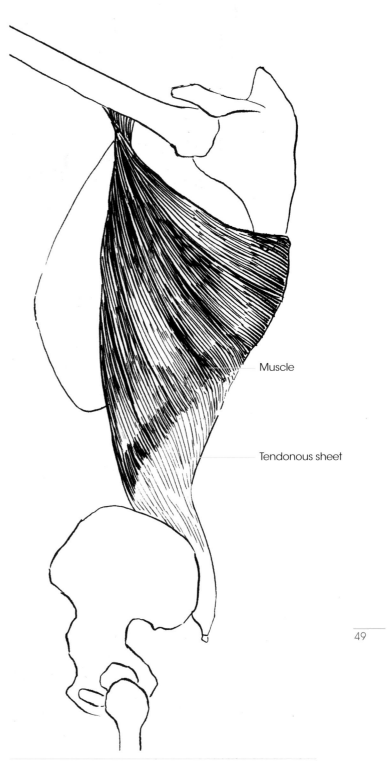

Muscle

Tendonous sheet

Fig. 5.18. Structure of the Latissimus Dorsi, Side

To feel the latissimus dorsi, sit sideways next to a table with your arm out and your palm on the table's surface; now push down on the table. With your free hand, you can feel the vertical border of the latissimus dorsi as it swells in front of the bottom corner of the scapula **(Figure 5.19)**. Keep pressing and follow the swelling as it goes into the armpit between the teres group and the biceps.

An examination of the armpit will provide an opportunity for another view of all the muscles that control the movement of the upper arm. If you raise your arm,

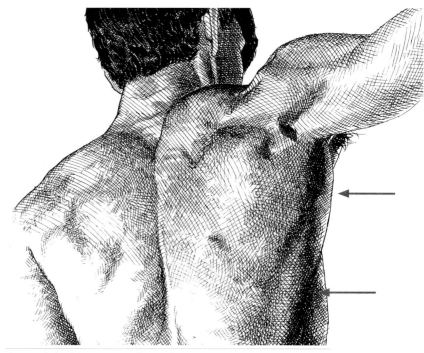

Fig. 5.19. Find Latissimus Dorsi over the Scapula

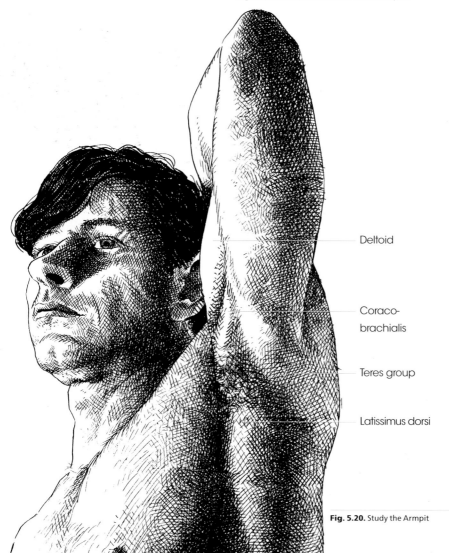

Deltoid

Coraco-brachialis

Teres group

Latissimus dorsi

Fig. 5.20. Study the Armpit

reaching your hand behind your head around to the opposite ear, you will be in a position to feel the relationship that these muscles have to each other **(Figure 5.20)**. Begin with the front and lower borders of the deltoid, feeling how it wraps up over the biceps to its insertion and down toward the clavicle where the end of the deltoid seems to merge into the outer edge of the pectoral.

Feeling down the edge of the pectoral, you can see that this muscle forms the front wall of the armpit. Feel the whole length of this side of the muscle, probing as hard as you can, straight down into the depth of the armpit. Keeping this position, move your exploring hand downward and feel how the armpit becomes shallow. As you do this, your fingertips will

50

come in contact with the hard surface of the rib cage, which here is only thinly covered by muscles. Move your fingers back slowly and painfully (if you do it right it should hurt a little) across this hard surface until they reach a significant mass of muscle, which is the latissimus dorsi. To see this muscle in its contracted state again, place your elbow on a sturdy shelf just above eye level and press downward. The latissimus dorsi will contract and become quite obvious both to the eye and hand **(Figure 5.21)**. In the mirror, the contracted latissimus dorsi will be a vertical line pointing to the side of the pelvis and extending on a slight incline up into the armpit. Feel the edge of the latissimus dorsi as it points up and into the armpit. If you explore carefully, you can feel how the fibers of this muscle twist up toward the humerus.

Immediately next to and rather difficult to distinguish from the latissimus dorsi is the teres group, paralleling the latissimus and inserted very near it on the humerus. The top edge of the latissimus dorsi and teres group, as they point onto the humerus, will disappear between the biceps and the triceps, and now your fingertips should be pointing onto the furrow between these two muscles. There is a small muscle wedged between the biceps on one side and the triceps and latissimus on the other, called the coraco-brachialis **(Figure 5.22)**. This muscle is visible only when the arm is raised (for which reason artists sometimes call it the crucifixion muscle), and plays a small role in pulling the arm down to the side.

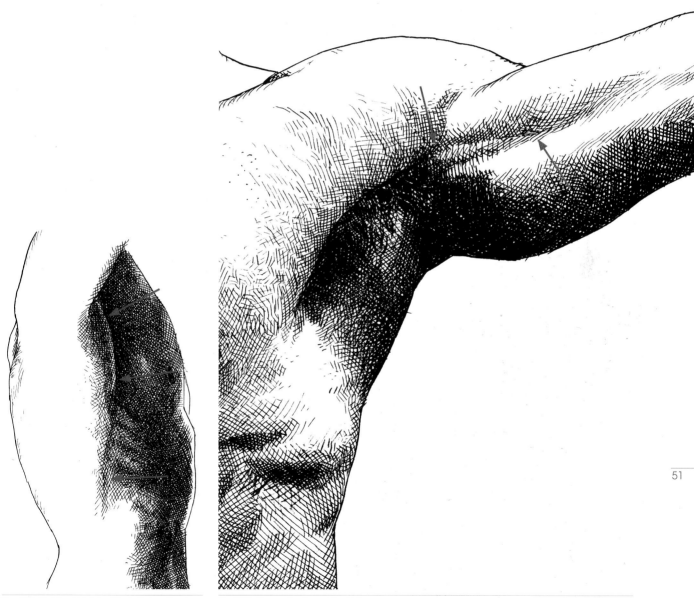

Fig. 5.21. Find Front Margin of the Latissimus Dorsi **Fig. 5.22.** Observe the Coraco-Brachialis

51

CHAPTER SIX

The Rib Cage and Shoulder Girdle

The rib cage, which serves as protection for the heart and lungs, consists of twelve pairs of curved strips of bone that meet the backbone or vertebral column in the back and, except for two of the ribs, the sternum in the front. The ribs connect to the sternum via a short strip of cartilage, the inherent flexibility of which allows the rib cage to expand and contract during breathing. This flexibility also provides greater resilience. The shape of the rib cage as a whole is rather like a flattened bullet, with the pointed end projecting through the shoulder girdle **(Figure 6.1)**. The broad, flat shape of both our rib cage and that of apes is different from that of most mammals, who have deep and narrow rib cages. The shape of the human and ape rib cage relocate the position of the scapulae away from the side to the back, which means the arms come out of the sides of the torso, rather than in front, as with other mammals. This was a great

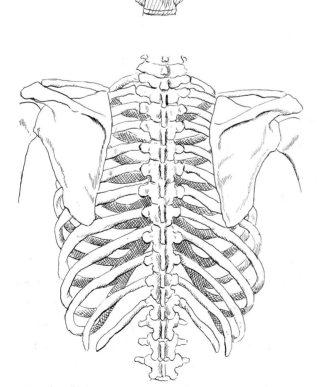

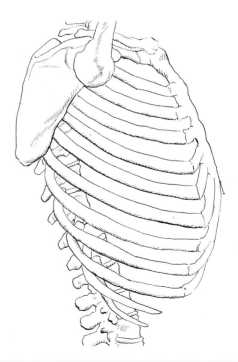

Fig. 6.1. Rib Cage

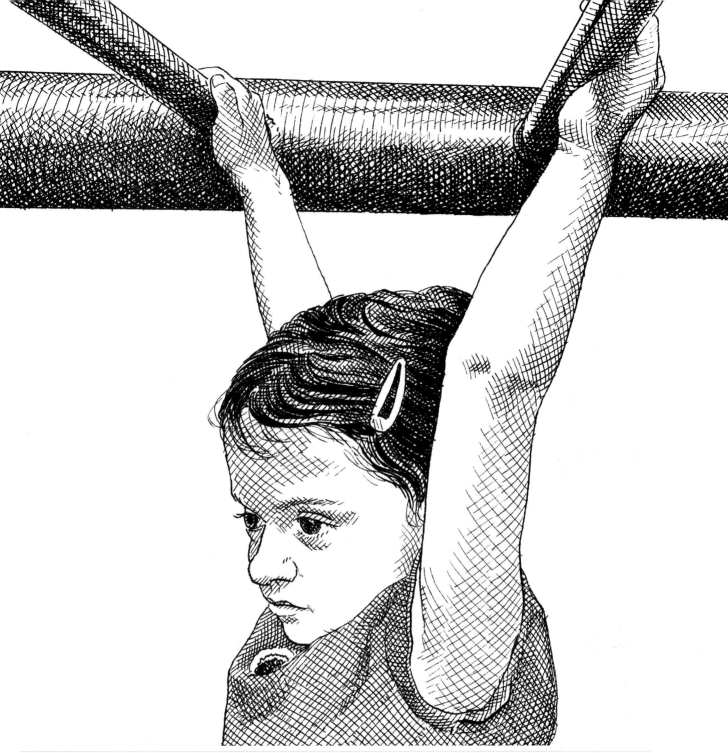

Fig. 6.2. Brachiation

advantage for our ape predecessors in hanging and swinging from branches **(Figure 6.2)**.

The first rib is intimately related to the shoulder girdle **(Figure 6.3)**. It is a flat ring that passes under the clavicle in front to meet the sternum; it tilts upwards about 30 degrees on its way to the eighth vertebra (numbering downward from the first vertebra in the neck). The other ribs follow a similar elliptical circuit as the first, but gradu-

ally increase the angle of their tilt as they proceed down the torso. The first six or seven ribs extend from the vertebrae to be inserted via an extension of cartilage into the sternum. As the costal, or rib cartilages descend along the chest, they progress from a horizontal orientation to a diagonal one, while at the same time increasing in length to meet the lower ribs, which extend beyond the length of the sternum. The cartilages of the seventh or eighth through the

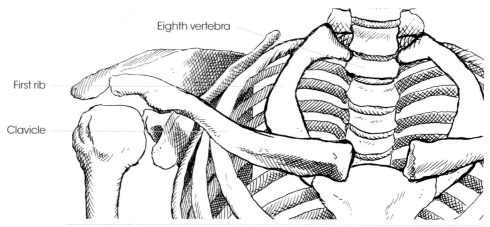

Eighth vertebra

First rib

Clavicle

Fig. 6.3. The First Rib

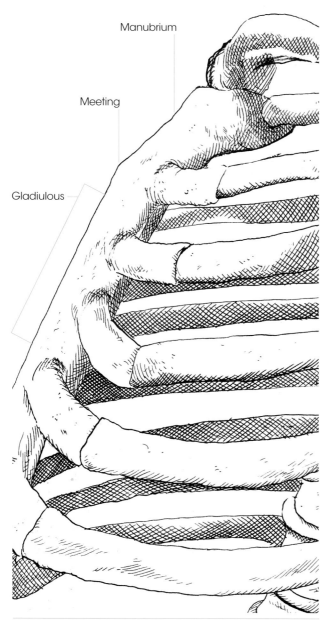

Manubrium

Meeting

Gladiulous

Fig. 6.4. Meeting of Manubrium and Gladiolus

tenth ribs fuse together on their way to the sternum, forming one unit that attaches to the bottom of the sternum.

If you suck in your belly very hard, you can feel the outline of this cartilage **(Figure 6.5)**. Starting at the pit of the stomach, which is the apex of the meeting of the two sides of cartilage, feel diagonally down along the edge of the cartilage. If you return your fingers to the pit of your stomach, you will feel the end of the sternum. The sternum is actually three fused bones: the xiphoid process, the gladiolus and the manubrium. The xiphoid process extends just below the insertion of the last cartilage from the sternum at the pit of the stomach **(Figure 6.6.)**. Feel a little upward along the center of your chest and your fingers will be on the gladiolus—the largest portion of the sternum—and then continue to feel up to where it joins the manubrium. This junction is a surface feature in some individuals; the change of angle that occurs there is a significant determinant of the profile of the chest. About two inches from the meeting of the manubrium and the gladiolus is the top of the sternum between the two ends of the clavicles **(Figure 6.4.)**. If you direct your touch downward again along the sternum and feel outwards toward the side of the chest, you will feel the alternating volumes of the ribs and indentations of the spaces between them.

There are also two last ribs, which, because they are attached only in the back to the vertebrae and not in front to the sternum, are called floating ribs **(Figure 6.7)**. These have little to do with either surface form or function. (They can even be surgically removed to change the contour of the torso—certainly a drastic remedy for a cosmetic effect.)

Fig. 6.5. Observe Bottom Edge of the Ribs

Fig. 6.6. Feel Xiphoid Process

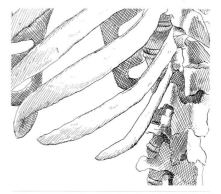

Fig. 6.7. The Two Floating Ribs

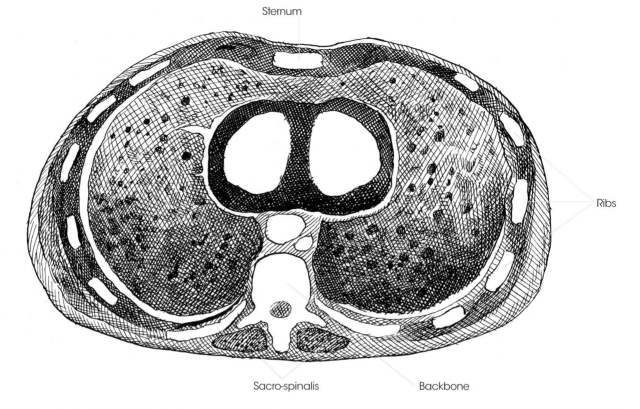

Sternum

Ribs

Sacro-spinalis

Backbone

Fig. 6.8. Cross Section of Chest

Fig. 6.9. Scapula Pulled Forward

Fig. 6.10. Socket and Ball of the Shoulder

The cross section shows that the ribs bow inwards toward the front of the torso before meeting the vertebrae **(Figure 6.8)**. This creates two indentations that run up the back on either side of the backbone. These indentations offer space for the sacro-spinales, a set of muscles that create two cylindrical volumes that, although covered, influence the form of the more superficial back muscles—especially the lower and thinner part of the latissimus dorsi. These two strips of muscle will be discussed in Chapter 11 along with the other muscles of our erect posture.

In the back, the ribs are covered by the latissimus dorsi, but are visible through this muscle especially when the back is relaxed and stretched, as in some bending and reaching poses **(Figure 6.9)**.

With this basic grasp of the rib cage you are prepared to go on to the muscles that attach the rib cage to the scapula and dictate the scapula's movements. The scapula, which was described earlier, is a flat triangular bone with a very notable projection or spine that runs near the length of the uppermost side. One of the angles of the triangle of the scapula is flattened into a shallow dish to receive the head of the humerus **(Figure 6.10)**.

The spine of the scapula, which we explored in Chapter 4, attaches at the outer end of the acromion process to the clavicle **(Figure 6.11)**. This junction you have also felt, as well as the length of the entire clavicle and its relation to the top of the sternum. It may be useful to review these pages that describe the shoulder girdle—and especially to review this part of your own body with your hands and eyes.

Each side of the shoulder girdle has a great range of movement. Either side can move from front to back, and slide up and down independently or in unison with the other. The only places of bony articulation that the shoulder girdle has to the rib cage—and therefore to the core of the body—are at the very small points of contact where each clavicle meets the sternum.

1 Spine of the scapula
2 Acromion process
3 Coracoid process
4 Clavicle
5 First rib
6 Top of sternum (the manubrium)

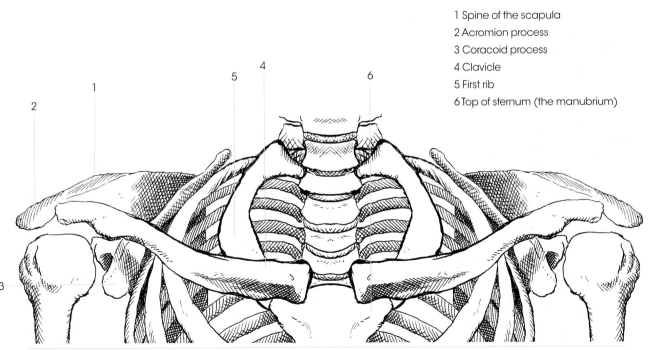

Fig. 6.11. The Shoulder Girdle

This full range of movement is something that you must explore on your own body, both looking in a mirror and feeling with your fingers. To understand the anatomy of the back, it is essential to fully comprehend the movement of the shoulder girdle and especially the placement of the spine of the scapula in these movements.

The forward movement of the scapula—away from the back, along the side of the body—is primarily the responsibility of the contraction of the serratus muscle. This muscle attaches to the ribs on the side of the chest in a diagonal arrangement **(Figure 6.12)**, and extends up to disappear beneath the latissimus dorsi. It then passes between the scapula and the rib cage, to be attached to the inner edge of the scapula. The serratus creates a diagonal bulge under the latissimus dorsi, which echoes the form of the scapula and is easily mistaken for the edge of the scapula

itself **(Figure 6.13)**. When this muscle contracts, it pulls the scapula downwards and forwards. This forward movement can be aided also by the pectoral muscle, which, although it is not attached to the scapula, influences it through its insertion in the humerus: in being pulled forward by the pectoral, the humerus naturally pulls the scapula along.

The backward movement of the scapula is caused by the contraction of two muscles: the rhombus[○] and the trapezius. The rhombus is attached to the seventh through thirteenth vertebrae, and makes a diagonal journey down to be inserted in the inner margin of the scapula. The contraction of the rhombus pulls the scapula in and up **(Figure 6.14)**. Most of the rhombus, however, is covered by a fascinatingly shaped muscle—the trapezius. The trapezius is attached to the back of the head, to all the vertebrae of the neck and rib cage, to the upper and lower margins of the spine of the scapula, and to the upper margin of the

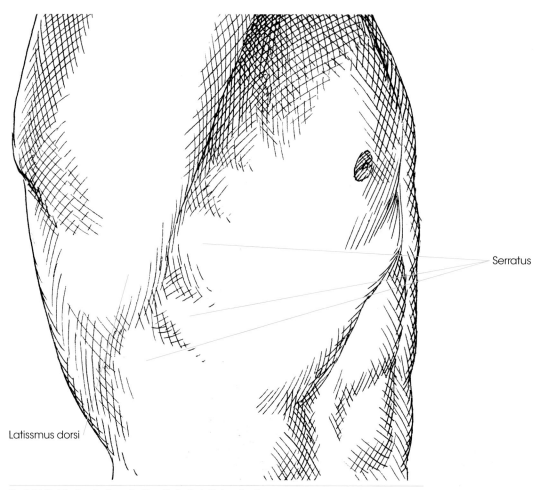

Serratus

Latissmus dorsi

Fig. 6.12. Find the Serratus Emerging From Under the Latissimus Dorsi

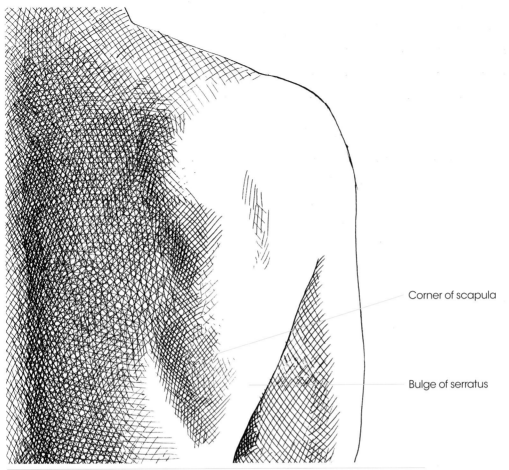

Corner of scapula

Bulge of serratus

Fig. 6.13. Differentiate Between the Bulge of the Serratus Under the Scapula

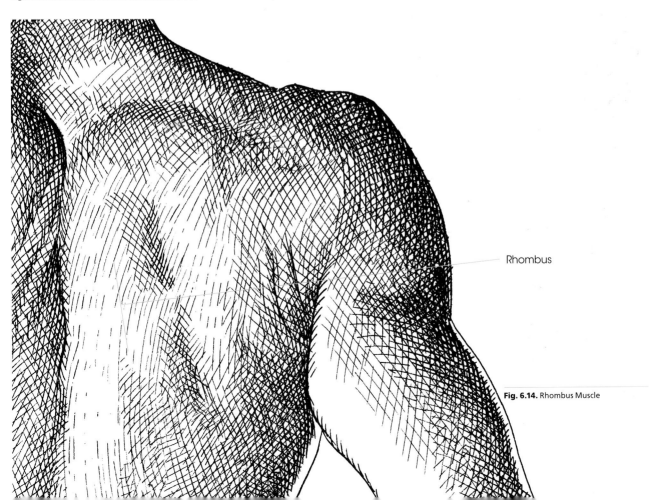

Rhombus

Fig. 6.14. Rhombus Muscle

outer one-third of the clavicle **(Figure 6.15)**. The complex form of the trapezius is a reflection of the variety of movements for which it is responsible: (A) its attachment to the back of the head allows it to help pull the head up and back; (B) its attachment to the clavicle and to the top of the spine of the scapula allows it to pull these bones up, in a shrug of the shoulders (the same contraction that shrugs the shoulders also completes the movement of raising the arm, which we discussed in relation to the deltoid muscle); (C) its attachment to the end of the spine of the scapula allows it, in conjunction with the rhomboids, to pull the shoulders back; and (D) its attachment to the bottom of the spine of the scapula allows it to pull the shoulders down **(Figure 6.16)**. For a bodybuilder to properly develop the entirety of the trapezius, each of these movements must be taken into consideration.

In the overall four-pointed star shape of the trapezius, it should be observed that there are two small but notable places where it becomes very thin and tendonous: first, at the base of the neck; and second, at the base of the rib cage. The trapezius partially covers a portion of the teres group, most of the rhombus, and some of the latissimus dorsi.

Fig. 6.15. The Trapezius

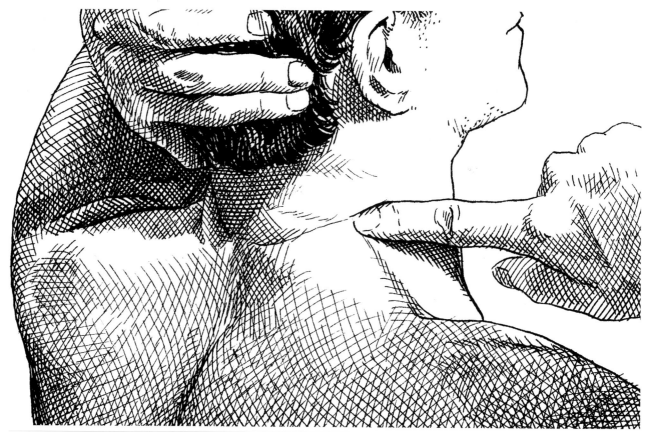

Fig. 6.17. Feel the Trapezius in the Neck

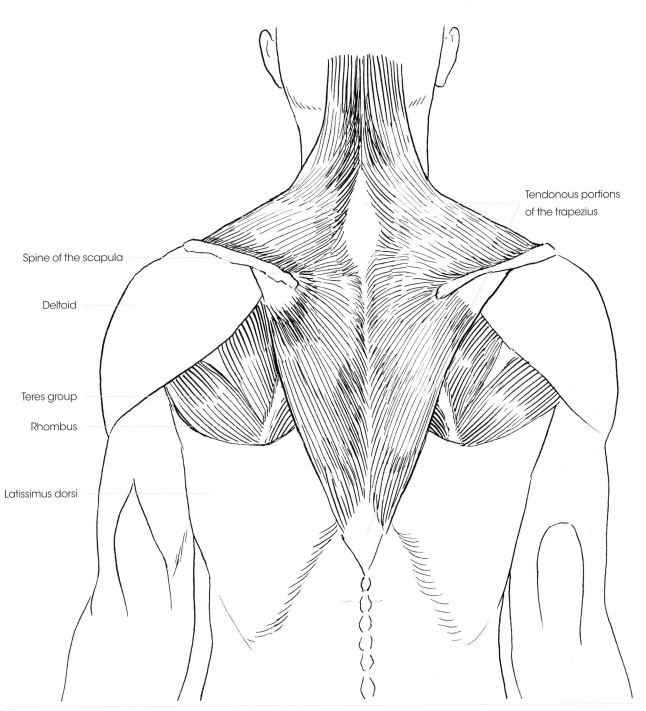

Tendonous portions
of the trapezius

Spine of the scapula

Deltoid

Teres group

Rhombus

Latissimus dorsi

Fig. 6.16. Structure of the Trapezius

The parts of the trapezius that are easiest to get to know on yourself are the portions in the neck and shoulders. Push your head back while restraining it with one hand. Use your other hand to feel the muscle as it contracts **(Figure 6.17)**. Now hunch your shoulders forward and shrug; you can feel the trapezius where it inserts into the clavicle and the spine of the scapula **(Figure 6.18)**. While in this position, notice the deep triangular depression between the trapezius and the clavicle and the neck. Also raise your arm to your side, feeling the deltoid as you lift it until the arm is horizontal, then feeling the trapezius as it comes into play in tilting the scapula so the arm can go even higher.

Back

Front

Fig. 6.18. Shrugging the Shoulders to Observe the Trapezius

A Reminder of Our Purpose

It would not surprise me if you were feeling a degree of impatience. Your impatience is probably two-fold: (1) you are getting just plain tired of anatomy and wonder if it's worth it; and (2) you're possibly also wondering if the approach of this book is really the one you want to spend your time on. So here, at this halfway point, I offer a reminder of your reason for studying anatomy and for studying it this way.

The typical anatomy text would explain the muscles in a sequence that would parallel either the construction or dissection of a body. In other words, it would either begin with the skeleton and in an orderly fashion pile up the layers of muscle and build a body from it; or else it would start with the superficial muscles and strip them away so that the deeper forms and their effect on the superficial could be revealed.

My method, because it is based not on structure but on function, is very different from either of these approaches. I start, for example, with the hand and the movements it can make, which leads us up the arm to the chest. The sequence is dictated by the movement that occurs in each of the joints along the way. The patterning of the muscles which cause these movements leads me deliberately to skip to deep layers and back up to superficial layers in a way that makes this book useless as an ordinary reference. If you want a fact about the structure of a particular part of the body, this is the wrong place to look. I am convinced that such knowledge is meaningless unless it

is informed by an understanding of function. The body is arranged in its structure to move in particular ways. If the movements are not systematically addressed, as they are here, the structure is just a pattern with no significance. The art student may think, as I did as a student, that he may not need what is being presented here, that he really just wants knowledge of the shapes of things. But knowledge of the body's shape is worthless if it does not derive from understanding of function. All great figurative art is about the why of the body—the meaning of the body—and the meaning of the body is movement and the potential for movement.

We celebrate the body through art forms that utilize it or depict it. We are driven to do this because it is what we are. We are bodies, and through our own bodies we empathize with others' bodies. That is what gives the arts that represent the body their power. I say this to remind you of the reason for the other peculiarity of my approach here: my insistence that you find everything I discuss on your own body through sight and especially touch.

If meaning, expression and empathy are not enough to persuade you that this approach is the most valuable one for studying skeleto-muscular anatomy, let it also be added that this approach is, in fact, easier in that when you learn it, it will be almost impossible to forget because the primary reference work you are being introduced to is always at your disposal—your own body.

The Foot

The poetic power of the foot is that through the foot we touch the earth. The flat, ground-embracing, arched and flexible—springful—foot was not always in the form we recognize. Our tree-dwelling ancestors, in fact, had lower appendages which terminated in what are better seen as hands. These "hands" of the lower body, like our hands today, were flexible and prehensile, capable of grasping and other more delicate manipulations. If you look at chimpanzees or orangutans in a zoo, the virtual interchangeability of the hands and feet should strike you **(Figure 8.1)**. The feet, or, as one may prefer to consider them, the "lower hands" of apes, are bigger than the upper hands and are a little less agile, but they have nearly opposable thumbs and can perform acts of which our stiff flat feet could never dream—unless in extreme necessity. Human infants born with useless or no hands will naturally use their feet for manipulations that are normally assigned to the hand. Of course, these children are limited by the lack of the opposable toes that apes possess, but their feet nonetheless develop a flexibility which makes them quite dexterous and capable of surprisingly deft manipulation. Such aptitude with the feet—which happens naturally and without coaxing—demonstrates the foot's memory of its hand-like origins. My use of the words *manipulation* and *dexterous* should be noted here since these words derive from the Latin words for hand (manus) and the right-hand side (dexter).

The primary difference between hands and feet (and this goes for the feet of apes as well) is the presence of a large bone forming the heel. The size of the heel bone and the large muscle attached to it give the foot leverage: in apes it propels them upward in climbing; in human beings it propels them onward in walking. Being more of a puller than a pusher, the human and ape hand has no need for a bone comparable to the heel. In human beings, the hand acts primarily to bring objects closer for examination. In apes, the hand

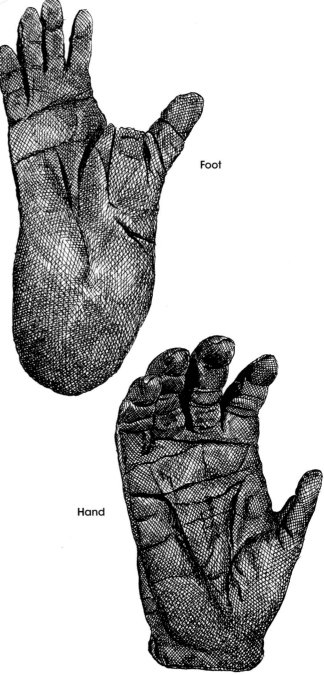

Fig. 8.1. Gorilla Foot and Hand

also has this function, as well as for catching and pulling tree limbs in climbing.

Our feet have a difficult job in serving us, the only bipedal mammals: they must bear the weight of the entire body over rough and uneven terrain, must be able to take this weight even under the powerful impact of running and jumping, and must have the spring to propel the body forward in these movements. So the foot needs strength, flexibility, spring and balance. The need for each of the qualities must be considered if the structure of the foot is to be understood.

The arch-like structure of the many bones of the foot is ideal for fulfilling these needs. The foot has two arches—one that runs toe to heel (lateral arch), and one (in the instep) that runs from side to side (transverse arch) **(Figure 8.2)**. The long lateral arch begins with the calcaneus, or heel bone. The back of this bone is a rounded surface that, when placing the foot forward and down in walking, is capable of meeting the ground at any number of points, depending on the length of the stride **(Figure 8.3)**. Attached over the heel bone and toward the front is the astragalus. These two bones are joined

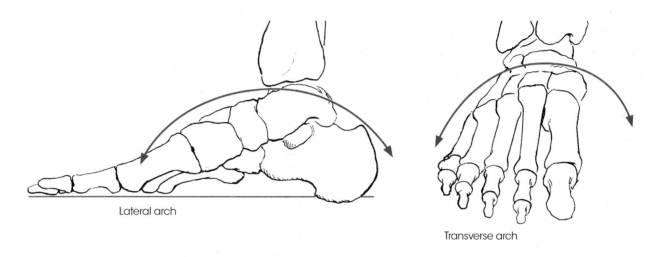

Lateral arch

Transverse arch

Fig. 8.2. Arches of the Foot

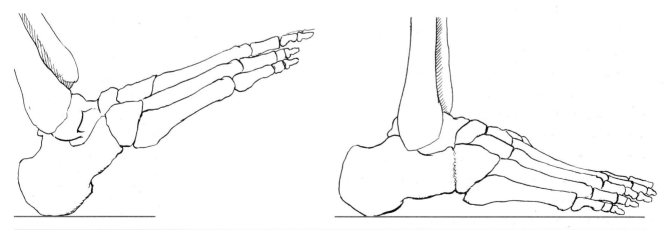

Fig. 8.3. How the Heel Meets the Ground

closely and make almost a single unit. This unit of the heel bone and astragalus forms the connection of the leg to the foot.

The astragalus has a smooth rounded surface **(Figure 8.4)** that fits beneath and between the two bones of the lower leg: the larger tibia on the inner side and, parallel to that, the thinner fibula on the outer side of the leg **(Figure 8.5)**. At the ankle, the tibia and fibula are tightly connected with ligaments. Both the tibia and fibula have bulbous ends that descend to the sides of the astragalus to keep the foot in place and limit the movement of the foot to a simple hinge-like up-to-down movement. Any side-to-side movement of the foot does not happen at the articulation of the foot to the leg but either within the structure of the foot itself or by movement in the leg as a whole. These two restraining knobs of bone, called the inner and outer malleolus, are the very prominent landmarks on each side of the ankle. The outer malleolus, which is the end of the fibula, is slightly further back, lower, and a little bigger than the malleolus of the tibia **(Figure 8.5)**. Students have asked me, at times, to remind them which malleolus is the lower one; I tell them that the answer is at the end of their own legs **(Figure 8.6)**. This is one obvious example of the need to learn to use your body as your primary reference.

Structurally, it is logical that the outer malleolus is lower if you remember that there is an outer malleolus on both sides of the body. The outer malleoli can be seen as little buttresses that push inward, keeping the legs straight. In this we see that the structure of both legs is conditioned by our bilateral symmetry. This is reflected throughout the foot: each foot tips toward the other; together they form the beginning of an inward thrusting post-and-lintel system, the side posts being the legs and the pelvis forming the lintel **(Figure 8.7)**.

The front of both the astragalus and heel bone end in articular surfaces that meet the navicular and the cuboid bones **(Figure 8.8)**: the navicular bone, which is attached to the astragalus, connects to the inner three toes via three intermediate block-like bones, the cuneiforms. The cuboid bone, attached to the heel bone, articulates directly to the outer two toes. The heel, the astragalus, navicular, cuboid and cuneiforms are together called the tarsals. We can see the tarsals as two groups: (A) the astragalus group, which is larger, articulates directly to the tibia and fibula, projects forward

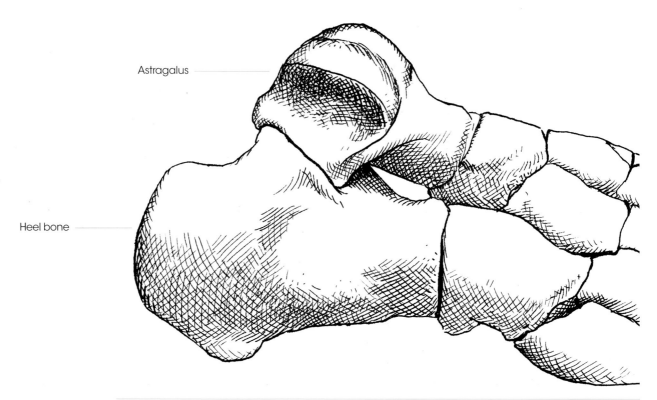

Astragalus

Heel bone

Fig. 8.4. Bones of the Heel

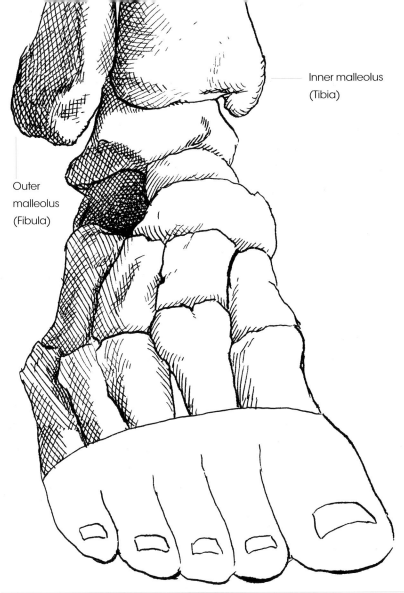

Inner malleolus
(Tibia)

Outer
malleolus
(Fibula)

Fig. 8.5. The Malleoli

Fig. 8.6. The Ankles

Fig. 8.7. Support of the Torso Begins at the Feet

67

I owe this analysis to the late R.B. Hale's lectures at the Pennsylvania Academy of Fine Arts.

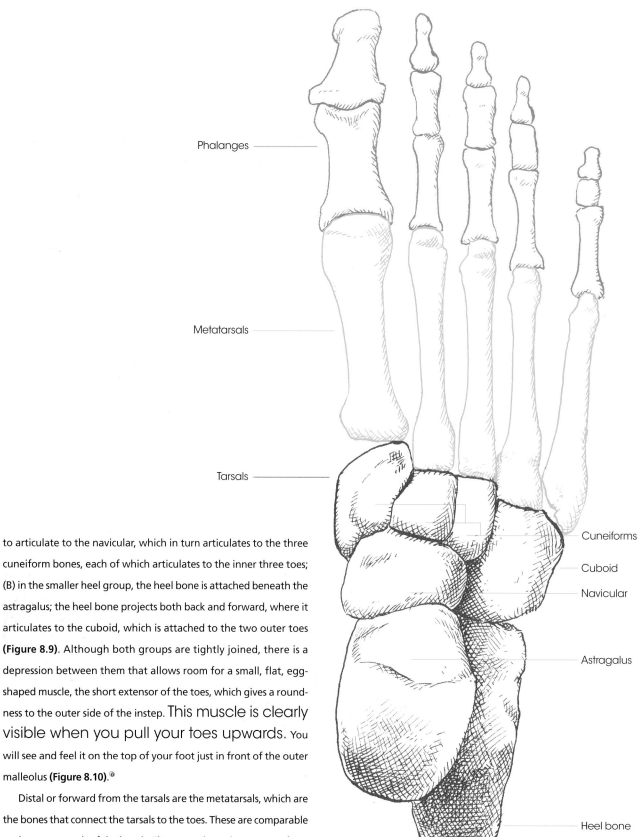

Phalanges

Metatarsals

Tarsals

Cuneiforms

Cuboid

Navicular

Astragalus

Heel bone

Fig. 8.8. Bones of the Foot

to articulate to the navicular, which in turn articulates to the three cuneiform bones, each of which articulates to the inner three toes; (B) in the smaller heel group, the heel bone is attached beneath the astragalus; the heel bone projects both back and forward, where it articulates to the cuboid, which is attached to the two outer toes **(Figure 8.9)**. Although both groups are tightly joined, there is a depression between them that allows room for a small, flat, egg-shaped muscle, the short extensor of the toes, which gives a round-ness to the outer side of the instep. This muscle is clearly visible when you pull your toes upwards. You will see and feel it on the top of your foot just in front of the outer malleolus **(Figure 8.10)**.[®]

Distal or forward from the tarsals are the metatarsals, which are the bones that connect the tarsals to the toes. These are comparable to the metacarpals of the hands. The toes, where they emerge from the mass of the foot and extend into separate appendages, are given

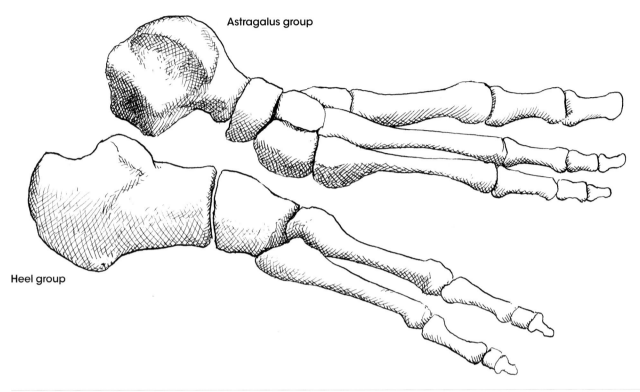

Astragalus group

Heel group

Fig. 8.9. Two Bone Groups of the Foot

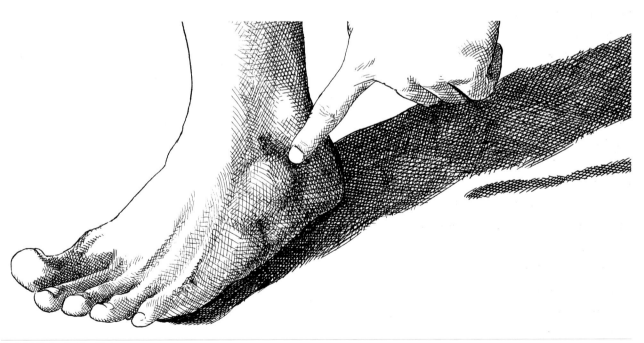

Fig. 8.10. Finding the Short Extensors

the same name as the comparable part of the hand: the phalanges. Unlike the fingers, which exceed the length of the metacarpals, the toes are much shorter than the metatarsals. Being used for standing and walking, the human foot doesn't require long toes—they would actually be in the way **(Figure 8.11)**.

The metatarsals are all nearly the same length. The inner metatarsal—that of the big toe—is much thicker, however, and the outer metatarsal—that of the little toe—has a heavy knob on its proximal end that adds to the inward buttressing thrust we've already seen in the ankle. This knob can be found on the outer side of the foot, not quite in front of and below the short extensor of the toes. If you move your fingers forward along the side of the foot from this knob, you will feel another small mass of bone; this is the joint of the metatarsal of the little toe to the phalange **(Figure 8.12)**.

Now examine inward across the top of the foot, and find all of the meetings of the phalanges to the metatarsals, especially noting the most massive of these in the big toe. The big toe, like the thumb (which in our ancestors it resembled closely), has only two phalanges, and, like the fingers, the other toes all have three phalanges each.

The lateral arch of the foot is at its highest along the inner margin of the foot, stretching from the heel to the meeting of the metatarsal and phalanges of the big toe. The spring of this arch is bolstered by two small bones on the sole of the foot that are embedded in a tendon that goes to the big toe from the heel. These two bones, called the sesamoids (meaning "seed-shaped"), serve as a wedge, supporting the arch **(Figure 8.13)**.

The bottom of the foot is well padded with tough fibrous tissue that protects the bones from constant impact with the ground. This padding also aids in making the foot hold the ground more effectively, much as a rubber-soled shoe affords more traction than a hard leather sole.

The arch of the foot is lowest on its outer margin, and, even though the bones of the little toe are arched, in most individuals there is padding that firmly meets the ground and that extends from the little toe to the heel. This relieves some of the pressure from the extreme ends of the arch at the ball of the foot and at the heel.

The anatomy of the foot cannot be further discussed without moving on to the muscles of the lower leg. The tendons that connect these muscles to the foot are essential in understanding its movement and structure.

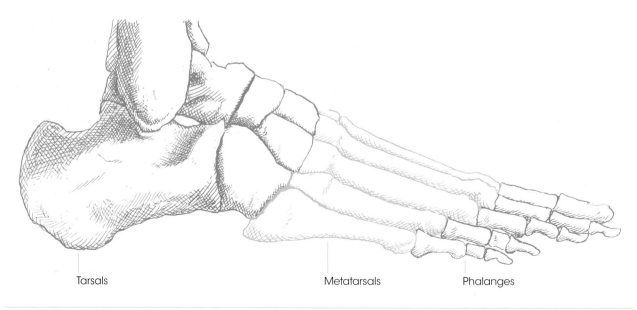

Tarsals Metatarsals Phalanges

Fig. 8.11. Side View of Foot Bones

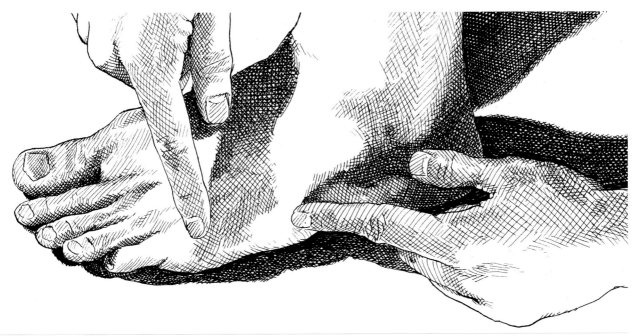

Fig. 8.12. Finding the Metatarsal of the Little Toe

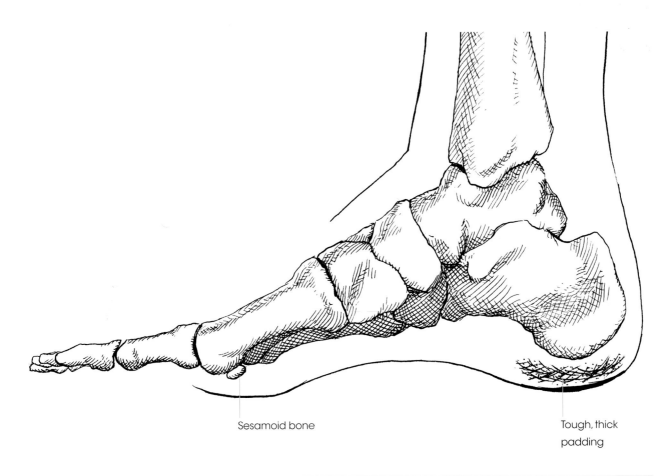

Sesamoid bone

Tough, thick
padding

Fig. 8.13. Sesamoid Bone of Foot

The Lower Leg

The foot, like the hand, acts as a marionette. Most of its movements are controlled by a set of strings—the tendons—which are pulled by muscles located in the lower leg.

The two parallel bones of the lower leg are analogous to the radius and ulna of the forearm, but unlike them they do not move in relation to each other. The sturdy tibia and the thinner fibula **(Figure 9.1)**, as we've already discussed, appear under the skin at the ankle as the inner and outer malleoli. Above the ankle, the fibula is covered by muscle tissue and only re-emerges near the knee, while the tibia has a subcutaneous surface all the way up the lower leg. This is commonly called the shin. It is a significant landmark and is quite easy to find. Begin by locating the inner malleolus, and feel upward along the bone as it continues up the inner side of the front of the leg. In the first six inches or so it is easy to confuse where the bone ends and where the major tendon in front of the shin begins. To distinguish bone from tendon, pull the toes up—the movement of this tendon will allow you to distinguish it from the tibia. Tendon can often feel as hard to the touch as bone, but unlike bone, it changes shape in movement **(Figure 9.2)**. Continue feeling upward while extending and releasing the toes until you feel where the tendon crosses over to the outer side of the shin and meets its muscle. At this point, the sharp front of the tibia can be felt **(Figure 9.3)**. In the skeleton, you can see that the tibia is triangular in cross section for much of its length; the front is the sharpest corner of this triangle and is what you should have just felt on yourself **(Figure 9.4)**. The shin bone is one plane of this same triangular column. Continue to explore up the lower leg with your fingers; as you approach the knee you will feel this plane of bone broaden considerably. Near the knee, the

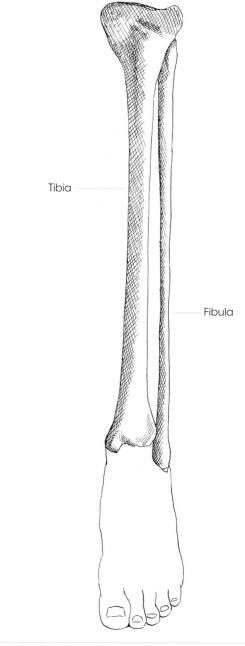

Tibia

Fibula

Fig. 9.1. Bones of the Lower Leg

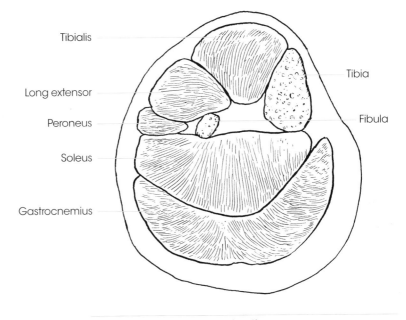

Tibialis

Long extensor

Peroneus

Soleus

Gastrocnemius

Tibia

Fibula

Fig. 9.4. Cross Section of Leg Through the Calf

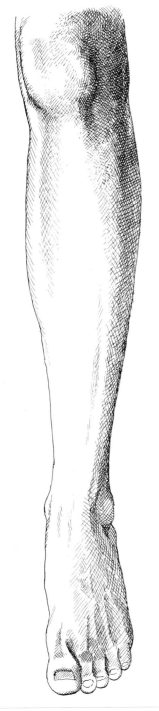

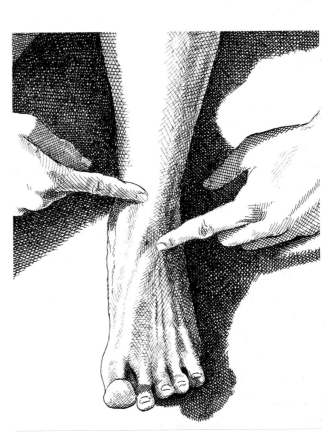

Fig. 9.3. Front of Leg Relaxed

Fig. 9.2. Distinguishing Tendon From Bone

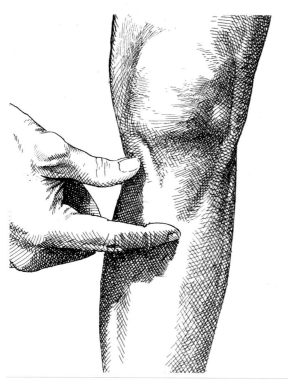

Fig. 9.5. Finding the Top of the Tibia

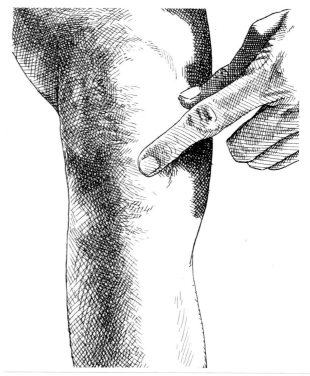

Fig. 9.6. Finding the Ligament of the Patella

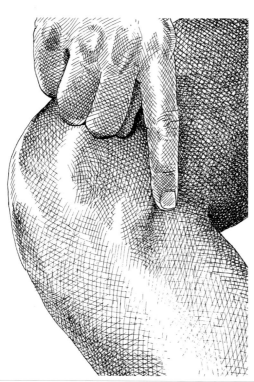

Fig. 9.7. Finding the Top of the Fibula

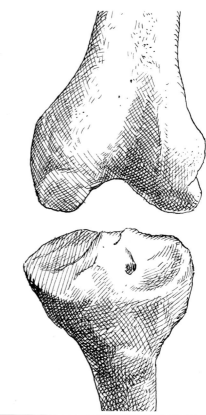

Fig. 9.8. The Femur Rests on the Top (Proximal End) of the Tibia

borders of the muscles on both sides of the tibia curve toward the back of the calf, exposing two broad faces of the tibia **(Figure 9.5)**. These two sides of the tibia meet in front at a rounded protuberance of bone, and above this is the kneecap, or patella. This rounded front of the top of the tibia is the part of the lower leg that meets the ground in kneeling. If you place your fingers in the space between the knob of the tibia and the kneecap and straighten your leg (I assume that you are seated), you can feel the movement of the thick, tough cord that connects these two bones **(Figure 9.6)**. This connective tissue that links two bones is, by definition, a ligament. But in terms of function it is more accurate to consider it a tendon that attaches the muscles of the front of the thigh to the tibia with the patella serving as a strengthening element suspended with the tendon. Considered

in this way, you will see why the patella is similar to the sesamoid bones with the sole of the foot. Feeling back along the outer side of the tibia, you can find how the rounded near end of the fibula emerges out from the muscles of the calf **(Figure 9.7)**.

In the skeleton, the top of the tibia can be seen as a flat, disc-shaped surface that cradles the bottom end of the femur, or thigh bone **(Figure 9.8)**. Just above the tibia you can feel the sides of the femur where it meets the tibia. Especially feel the slight furrow that runs around the knee joint between these two bones. When the leg is bent, the tibia slides behind the end of the femur, and in this position the form of the end of the femur is quite clear, especially in thin individuals **(Figure 9.9)**. Also note how the patella tilts back and rounds off the angle of the bent leg **(Figure 9.10)**.

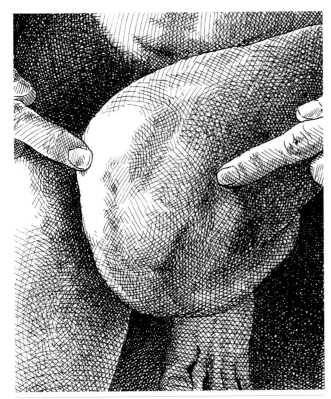

Fig. 9.9. Finding the Distal End of the Femur

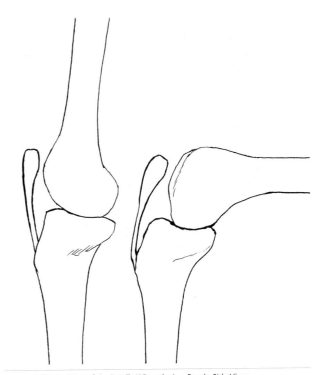

Fig. 9.10. The Position of the Patella When the Leg Bends, Side View

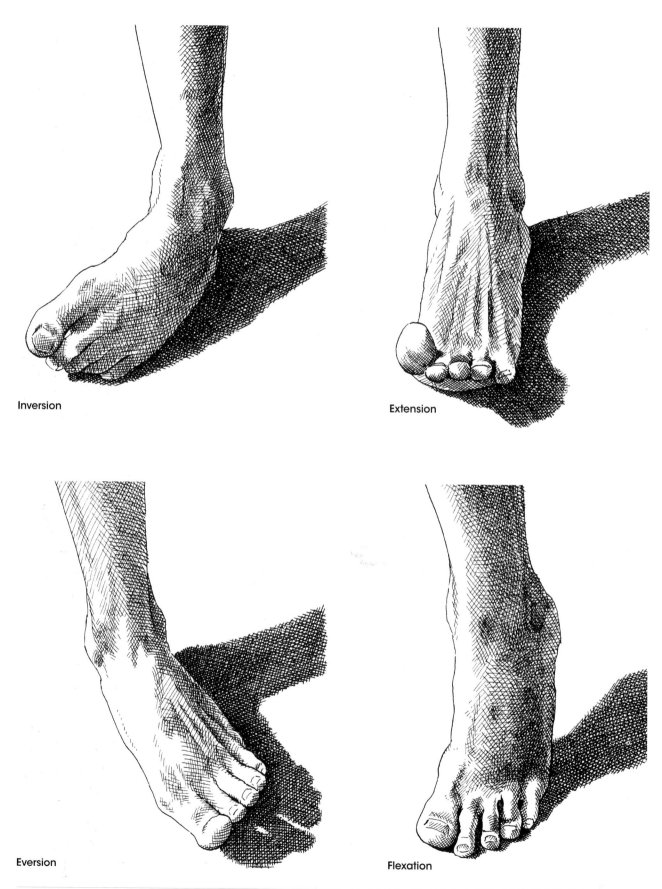

Inversion

Extension

Eversion

Flexation

Fig. 9.11. The Four Movements of the Foot

The muscles of the lower leg, all of which are inserted into the foot and control its movements, are readily intelligible if the movements of the foot are observed and remembered. The foot is capable of four basic movements: inversion (tipping inwards); extension (pulling upward); eversion (tipping outward); and flexation (pointing downward) **(Figure 9.11)**. The muscles that control these movements are all basically parallel to each other and occur logically in order around the girth of the lower leg.

Inversion: Find the front edge of the tibia, and turn your foot inward. Feeling outward, right next to this edge of bone you will find the tibialis muscle as it contracts to perform this movement. Feel down toward the foot and find the tendon that connects the tibialis to the inner side of the metatarsals as it crosses over the front of the tibia. In the skeleton you can see how the front edge of the tibia flattens here to make room for the course of this tendon. Continue relaxing and contracting the tibialis until you feel its full length and breadth along the length of the shin in the front of the leg **(Figure 9.12)**.

Extension: With your heel on the ground, pull up the front of your foot and toes.[○] You will see and feel the long extensors of the toes running up the front of leg next to the tibialis. The tendon of the long extensor lies just outside the tendon of the tibialis. As this tendon progresses to the foot it splits into separate tendons, which go to each toe. These fan outward much as you have already seen the extensors of the hand fan out to the knuckles. The outer side of the long extensor tendon passes just in front of the outer malleolus. The tendons of the tibialis and the long extensors soften the profile of the joining of the foot to the leg. Between them you will find a small concave plane. Tendons, being cords under tension, strive to be straight lines; however, the concavity of the profile of these two tendons is caused by a ligament that encircles the ankle and holds the tendon in towards the bone **(Figure 9.13)**. This ligament is analogous to the one that holds the carpal tunnel together (see page 20).

Eversion: This is accomplished through the two peroneus muscles. The rounded body of the most prominent of these is just behind the long extensor on the side of the leg, just below the top of the fibula. It is easily found when the foot is pulled up to the outer side. The swelling of the peroneus in contraction is accompanied by a depres-

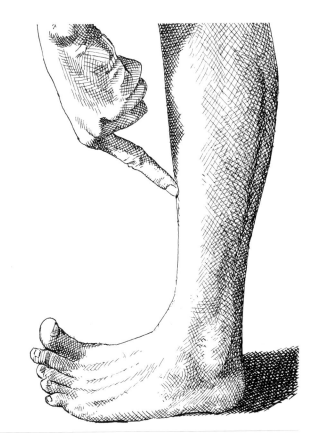

Fig. 9.12. Finding the Tibialis

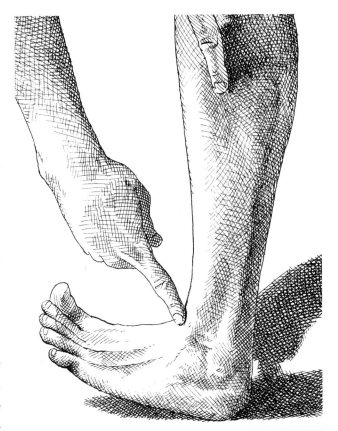

Fig. 9.13. Finding the Extensors

○ At first this movement does not seem like extension until you compare it to the extension of the fingers; when you fully extend the fingers you pull them up away from the palm, just as in extending the toes you pull them away from the sole of the foot.

77

sion of the tissue just below it, which makes the fullness of the muscle even more clear **(Figure 9.14)**. Feeling down the side of the leg, the tendon of the peroneus emerges clearly to the touch and then to the sight as it makes its course behind the outer malleolus to be inserted in the outer side of the heel bone where it meets the cuboid bone. Contract the muscle as much as possible by pulling the side of the foot up, and feel the entire extent of the peroneus tendon as it angles around the malleolus and makes a diagonal line on the side of the foot. This will be more visible on some individuals, but it will be feelable in all **(Figure 9.15)**. Remember that the tendon of the peroneus passes behind and the tendon of the long extensor passes in front of the outer malleolus of the fibula.

Flexation: The calf, the muscle mass of the back of the lower leg, points the foot. It far exceeds in volume and strength the muscles of the other three movements of the foot combined **(Figure 9.16)**. This makes sense when you consider that these other three movements have only the weight of the foot itself to deal with, while the act of flexing the foot must lift the weight of the entire body. The larger the foot is in proportion to the height of the body the more effective it is as a lever; this means that all else (i.e., the person's weight and degree of physical fitness) being equal, the calf will be smaller and weaker the larger the foot. Since women usually have proportionally smaller feet than men, they tend to have fuller calves.

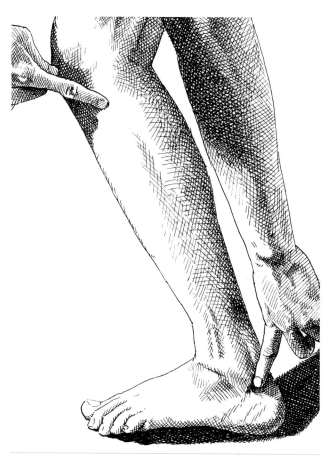

Fig. 9.14. Finding the Peroneus

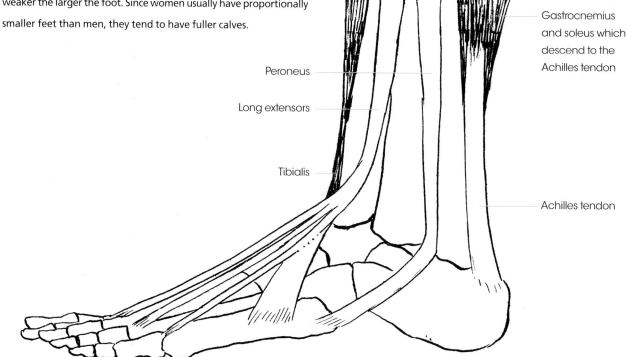

Peroneus

Long extensors

Tibialis

Gastrocnemius and soleus which descend to the Achilles tendon

Achilles tendon

Fig. 9.15. Tendons of the Foot

Fig. 9.16. The Calf in Flexation

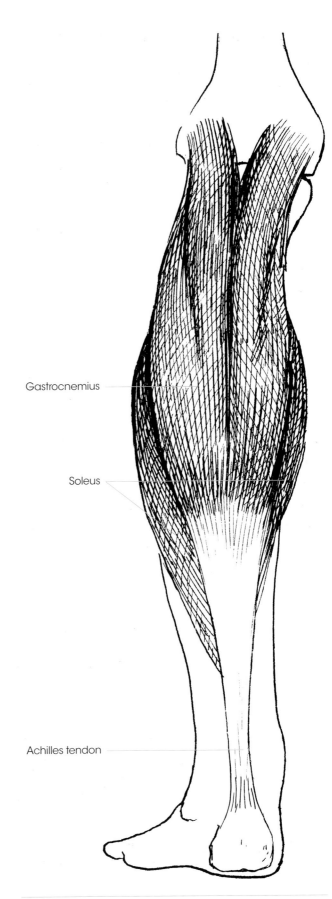

Gastrocnemius

Soleus

Achilles tendon

Fig. 9.17. The Calf Muscles

There are two calf muscles: the deeper, broader and shorter soleus, and the superficial and longer gastrocnemius **(Figure 9.17)**. The soleus begins near the top of the back of the tibia and goes into the massive tendon at the back of the ankle, the Achilles tendon, which is inserted into the back of the heel **(Figure 9.18)**. The gastrocnemius originates in the back of the femur as two separate muscle masses that merge and also enter the Achilles tendon. Although the gastrocnemius covers the soleus, both sides of the soleus can be seen peeking out from beneath the gastrocnemius and higher part of the Achilles' tendon.

To feel these muscles, point your foot as strenuously as possible. At the back of the knee joint, you will feel the gastrocnemius contract. Continue to feel downward on the calf, grasping the entire mass of it with your hand. You should feel the inner portion of the gastrocnemius descending lower than the outer portion. To each side of the rounded mass of the gastrocnemius, you will see the inner and outer margins of the soleus descending diagonally toward the heel **(Figure 9.19)**. Now, alternately pointing and relaxing your foot, feel the Achilles tendon as it gathers the muscles of the calf and inserts into the heel. Notice the space between the tendon and the malleoli on each side of the ankle **(Figure 9.20)**.

In examining the muscles of the leg and the movements of the foot, we have passed from the edge of the tibia outward to the side of the leg, continuing behind to the calf. If the full breadth of the calf is felt forward to the inside of the leg, you will find that your exploration completed a circuit around the lower leg to the subcutaneous face of the tibia again.

Fig. 9.18. Finding the Soleus

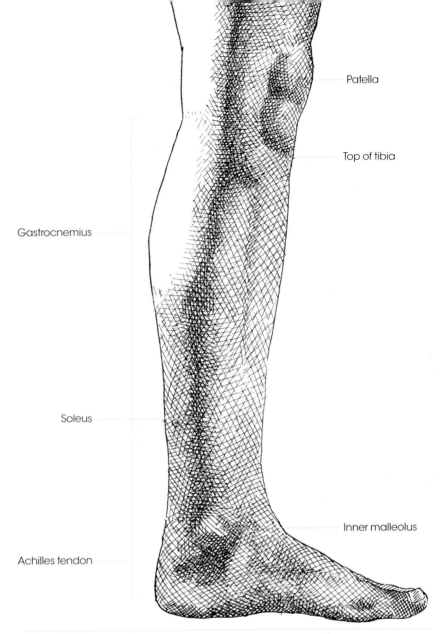

Patella

Top of tibia

Gastrocnemius

Soleus

Inner malleolus

Achilles tendon

Fig. 9.19. The Lower Leg

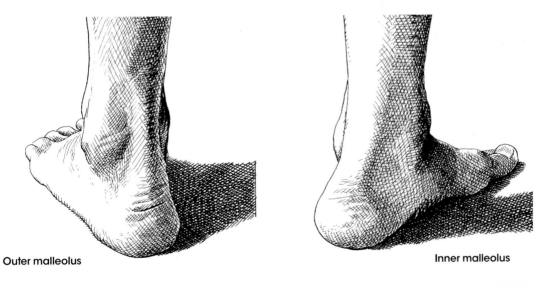

Outer malleolus

Inner malleolus

Fig. 9.20. Observe the Distance Between the Malleoli and the Achilles Tendon

The Thigh and Pelvis

The femur, or thigh bone, is the longest bone in the body. When we stand, its lower end, as we have just seen, rests on the top of the tibia's dish-like surface. In our tree-dwelling relatives, the femur ascends in a straight line from the tibia, but in human beings it ascends at a slight angle, which makes the human skeleton a little knock-kneed **(Figure 10.1)**. The advantage of this is that the weight of the body is placed more directly over the knees and feet, thus reducing the outward strain at the knees and ankles. The articulation of the femur to the pelvis is a beautifully fitted ball-and-socket joint, the ball of which connects to the shaft of the femur through a short neck **(Figure 10.2)**. At the meeting of the shaft and neck of the femur there are two prominent bone masses, the greater and lesser trocanters. The greater trocanter especially concerns us because, besides being an important location for the insertion of muscles, it has a visible effect on surface form even though it is not directly beneath the skin.

The pelvis, through which the femurs support the whole torso, is a modified bucket. This bucket must hold up the guts, but it also needs an opening through which waste and babies can pass. Consequently, the pelvis is wider on top to receive the guts and narrower on the bottom to contain them; the narrower end is strung across with a series of muscles which are elastic enough to move aside when something has to pass through the bottom opening. The front of the pelvis is lower than the back so that there is room for the guts to expand in gorging, obesity or pregnancy. The back of the pelvis connects to the rest of the skeleton via the vertebral column.

The entire pelvic girdle **(Figure 10.3)** is made up of three bones: the two haunches, plus the sacrum, which connects the pelvis and lower legs to the vertebra and the rest of the body. The two haunches almost meet in front: their joining is cushioned by a small disc of cartilage which allows some minimal expansion and contrac-

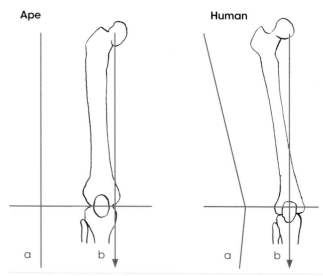

Fig. 10.1. Comparison of the Relationship Between Femur and Knee Joint in Apes and Humans

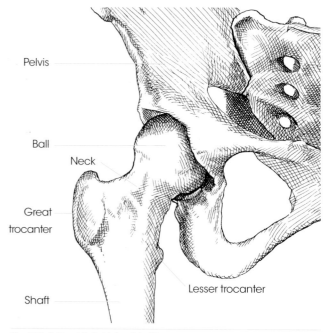

Fig. 10.2. Ball-and-Socket Joint of the Hip

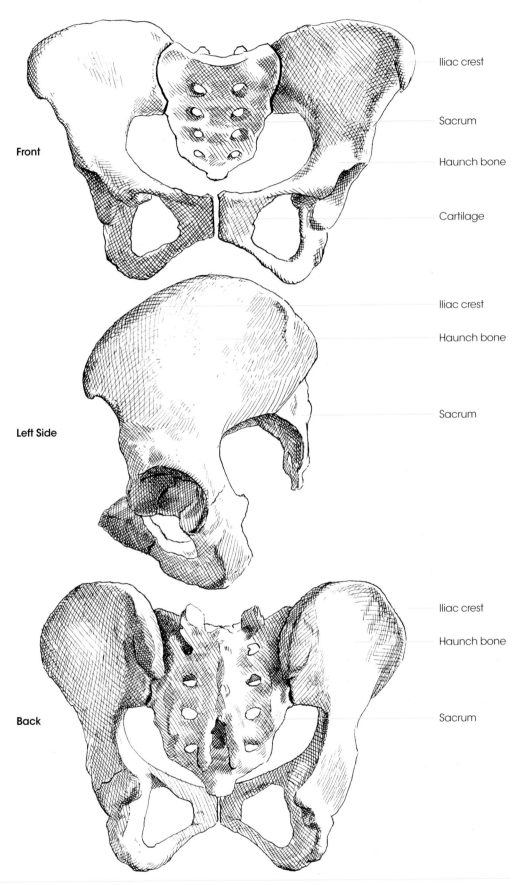

Front

Left Side

Back

Iliac crest

Sacrum

Haunch bone

Cartilage

Iliac crest

Haunch bone

Sacrum

Iliac crest

Haunch bone

Sacrum

Fig. 10.3. Pelvis

83

Fig. 10.4. Finding the Sacrum

tion, especially for women in childbirth. In back, the haunch bones meet with the triangular sacrum. The lower end of the sacrum has a small pair of bones, the coccyx, which is the vestigial remains of a tail, and is not worth much notice to artistic anatomists; artists of movement should be aware of the coccyx because it is subject to injury. The sacrum is a curved triangle, the top of which tips forward toward the belly. Two knobs of bone, one from each haunch, slightly overlap the two top corners of the sacrum behind. These two knobs are clearly visible as the dimples or knobs on the top of the buttocks. The greater the body fat, the deeper these dimples become; in the emaciated, the tissue surrounding these knobs of bone recedes and they are visible as bumps. Feel the top of the cleft of the cheeks of your buttocks while you are examining these knobs on yourself. There, between the top of the cheeks, the lower end of the sacrum can be felt. These two knobs and the top of the buttock cleft are significant landmarks: together they form a triangle which will help you locate the position of the pelvis **(Figure 10.4)**.

Fig. 10.5. Finding the Front of the Pelvis

In front, you will find a prominent bone on each side of your belly, a little below the level of your navel. These are the fronts of the crests of the haunches that reach back to the two knobs near the sacrum. Just over the genitals, near the top of the pubic hair, the meeting of the two haunch bones is feelable. These three palpable locations of bone form a triangle in the front of the body that is as essential to accurate understanding

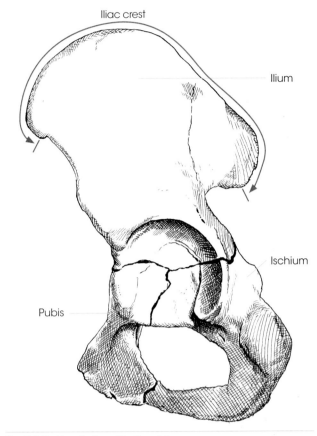

Iliac crest

Ilium

Ischium

Pubis

Fig. 10.6. The Three Sections of the Haunch Bone

of the position of the pelvis as the corresponding triangle in the back **(Figure 10.5)**.

Each haunch bone begins in the fetus as three separate bones that fuse in development **(Figure 10.6)**. The three sections all meet at the socket for the femur and are as follows.

The Ischium: This is the lower and back portion of the haunch. It is discernible to the touch while in the seated position: place your hand between your behind and the chair—the place where there is the greatest pressure on your hand is the hard knob of the ischium. When you are standing, this bony mass is covered by the muscles of the buttocks, but these muscles glide to the side in sitting so that they are not crushed by the weight of the body between the bone and the surface sat upon **(Figure 10.7)**. The bone is protected by a layer of tough connective tissue that is quite like the tissue that covers the other part of the body that must repeatedly bear the body's weight: the heel.

The Pubis: This is the front portion of each haunch. They meet each other as they arch forward from the ischium to join at the bottom of the torso just over the genitalia. You should have already found this **(Figure 10.5)**.

The Ilium: This is the largest section of the haunch. In feeling the knobs near the sacrum and those on each side of the belly, you have already found the two extreme ends of the iliac crests which are the two sides of the pelvis. The ilia are slightly concave to make room for the massive muscles which originate in them. Just below the front of the iliac crest there is the lower iliac spine, a small knob of bone that is too deep to feel, but which you need to know about because it is the origin of an important muscle of the thigh. With this just-sufficient knowledge of the pelvis and femur, the movements

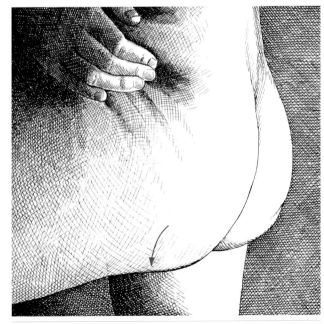

Fig. 10.7. Finding the Ischium

and muscles for which these bones provide the armature will be easy to grasp.

There are seven basic movements **(Figure 10.8)** that originate in the pelvis: pulling the thigh backward; bending the lower leg; pulling the legs together (adduction); pulling the thigh forward; straightening out the lower leg; rotating the thigh; and pulling the legs apart (abduction). Of course, before going further, perform all of these movements yourself. Notice that movement between the lower leg and thigh is in only two directions, while between the pelvis and thigh it is in all directions. This is analogous to what you have already seen in comparing the knuckle joints to the finger joints and the shoulder joints to the elbow joints. In each of these cases the ball and socket (and hence the more movable joint) is within a massive unit of the body. The knuckle is in the mass of the hand, the shoulder is in the mass of the upper body, and the pelvis and femur joint is in the mass of the pelvis. The simpler hinge joints of the fingers, legs and elbows are out in the midst of the extremities. The greater movement of the ball and socket requires that it be embedded in a bodily mass so that it is supported and directed by a range of muscles. Since there is no room for such a range of muscular support and control in the extremities, support must be provided by bone, which limits movement while it provides strength.

You can now explore the thigh and see which muscles control these seven movements.

Pulling the thigh backward and bending the lower leg: Looking at the thigh from behind, the major group of muscles seen are the hamstrings, actually three separate muscles **(Figure 10.9)**. The hamstrings originate at the knob of the ischium under the buttocks, and, as they descend the thigh, separate into a pair of muscles on the outer side and one on the inner side and insert on opposing sides of the tibia. In separating they make room for the two ends of the gastrocnemius to originate between them on the femur. In conjunction with the gastrocnemius, the hamstrings (so called because they are stringy and are in the ham, or leg) bend the lower leg toward the back of the thigh. When they work alone they pull the entire leg and thigh back toward the buttocks.

Adduction: Closing the thighs is accomplished by a series of muscles that are attached to the bottom of the pubic region through massive tendons, and that extend down the leg and fan out to be inserted all along the inner side of the thigh **(Figure 10.10)**. If

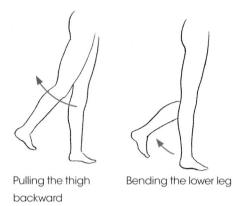

Pulling the thigh backward

Bending the lower leg

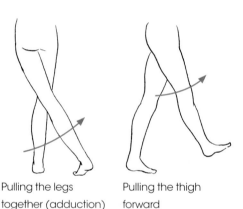

Pulling the legs together (adduction)

Pulling the thigh forward

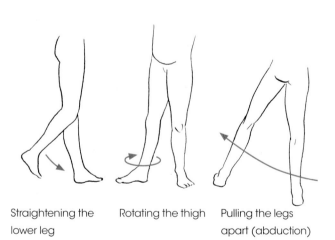

Straightening the lower leg

Rotating the thigh

Pulling the legs apart (abduction)

Fig. 10.8. The Seven Movements of the Legs

you spread your legs wide apart, you will see the almost cylindrical mass of these tendons emerging from the groin **(Figure 10.11)**. The longest and most superficial of these adductors is the gracilis. Unlike all the other adductors, it is inserted not into the femur but into the inner side of the tibia. It adds to the fleshy roundness on the inside of the knee **(Figure 10.12)**; this roundness is especially visible if you bend your leg sharply and press the muscles of the calf against the back of the thigh.

Pulling the thigh forward: In close association with the adductors is a group of muscles that help pull the thigh forward and upwards. This group is the ilio-psoas, which begins on the vertebra and the inside of the iliac crest **(Figure 10.13)**. For most of its length it is covered by the gut, but it emerges over the front lower margin of the pelvis and is inserted in the inner side of the femur on the lesser trocanter. In contraction, this muscle group pulls the thigh up, which it does with the aid of a muscle in the front of the thigh—the rectus femoris.

Straightening the lower leg: The quadriceps make up most of the muscles in the front of the thigh. As the name implies, this group consists of four muscles: the rectus femoris, the vastus internus, the vastus medialis and the vastus lateralis **(Figure 10.14)**. The vastus internus is covered by the other three so we can almost forget about it, just remembering that it adds bulk to the front of the leg. The vastus muscles all originate in the femur. The lateralis is on the outer side of the bone and the medialis on the inner side. They are both inserted into the patella—the lateralis on the outer side and medialis on the inner side. The lateralis, which is thinner and longer, starts up higher on the femur and comes into the patella a little higher, while the thicker medialis starts lower and meets the patella lower. As a group they form a kind of asymmetrical teardrop. Coming straight down from the pelvis is the rectus femoris, which begins at the lower, smaller knob in front of the ilium, and is inserted in the top margin of the patella. The small rounded patella visibly receives three of the four massive quadriceps muscles, two from each side and one from straight above. It is via the patella and the patellar ligament that connects it to the front of the tibia that these muscles, in contraction, pull the front of the lower leg forward to straighten the leg.

Rotating the leg: The long thin sartorius muscle, which originates at the front of the iliac crest, lies between the margins of the quadriceps and the adductors **(Figure 10.15)**. Although this muscle

is rarely visible except in very strained positions **(Figure 10.16)** or on bodybuilders, it is visually important as the boundary line where the form of the thigh changes between the outward bulging roundness of the quads and inward bulging roundness of the adductors. The insertion of the sartorius into the tibia just in front of the insertion of the gracilis also contributes to the roundness on the inner side of the knee. In contraction, the long spiral of the sartorius rotates the leg so the foot points outward.

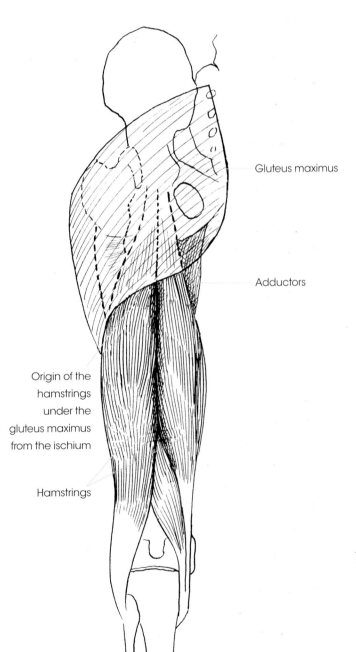

Gluteus maximus

Adductors

Origin of the hamstrings under the gluteus maximus from the ischium

Hamstrings

Fig. 10.9. The Hamstrings

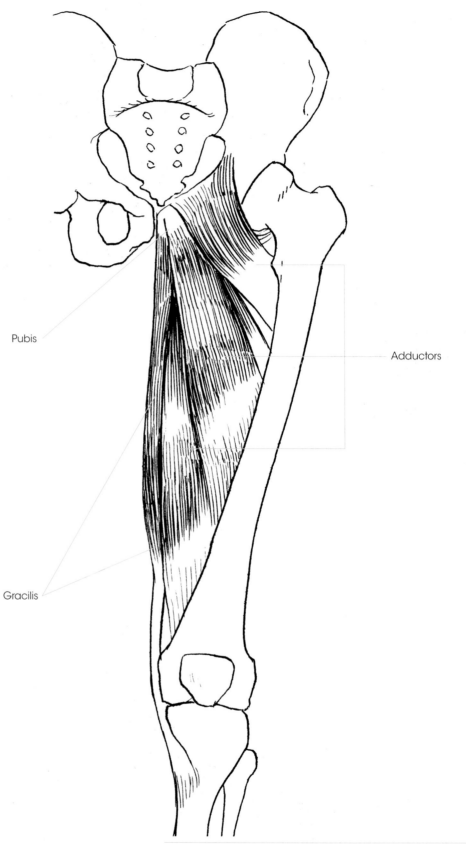

Pubis

Adductors

Gracilis

Fig. 10.10. The Adductors

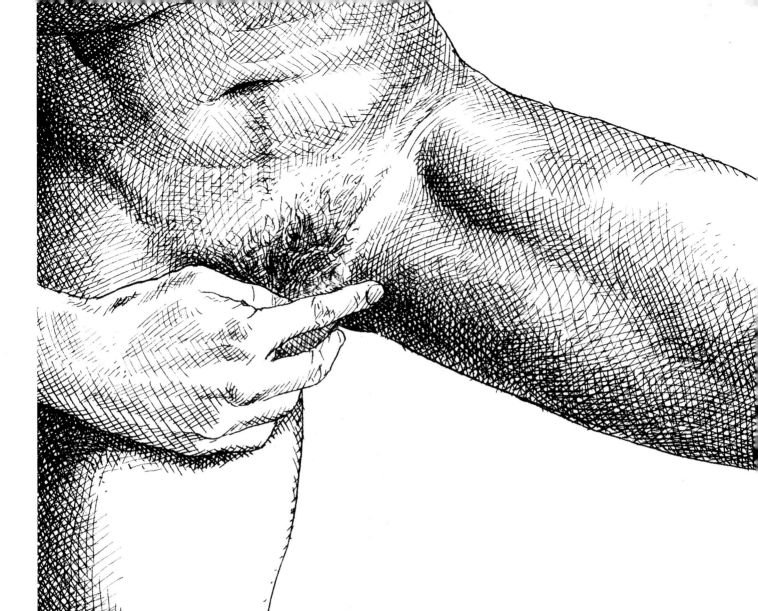

Fig. 10.11. Finding the Tendon of the Adductors

Fig. 10.12. The Distal End of the Gracilis at the Inner Side of the Leg

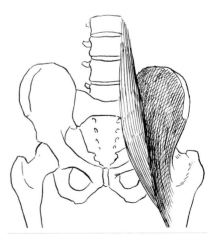

Fig. 10.13. The Ilio-Psoas Group

Rectus
femoris

Vastus
lateralis

Vastus medialis

Patella

Patellar ligament

Fig. 10.14. The Quadriceps

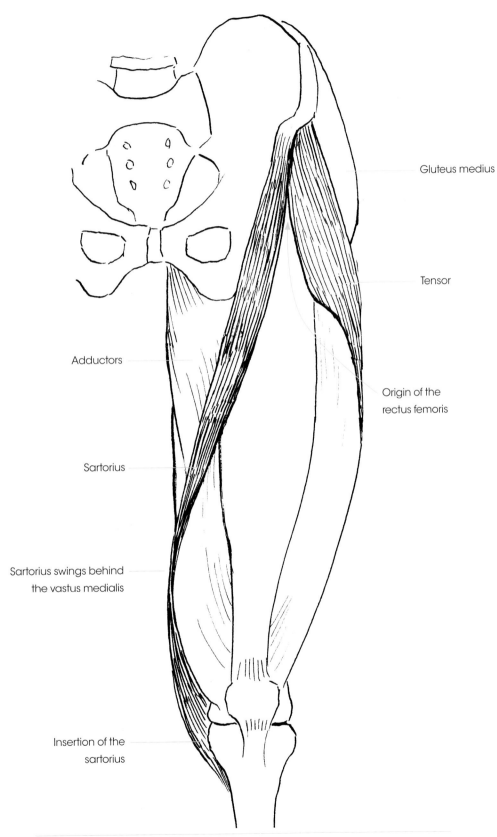

Gluteus medius

Tensor

Adductors

Origin of the
rectus femoris

Sartorius

Sartorius swings behind
the vastus medialis

Insertion of the
sartorius

Fig. 10.15. The Sartorius and Tensor Muscles

Abduction: Also beginning at the front of the iliac crest is the tensor muscle. The tensor and the sartorius originate next to each other, and both take diagonal routes to the outside and inside of the leg, respectively. Together they form an inverted V. The rectus femoris, which originates just beneath them, emerges at the apex of this V **(Figure 10.17)**. The meeting of the sartorius and tensor over the origin of the rectus can be seen only in thinner individuals and only in a very strained posture: standing on one leg and bending slightly at the knee. If an average individual palpates deeply in the right location, in this position, the interplay of these muscles can at least be felt.

In its diagonal course, the tensor muscle goes to just below the great trocanter. This bony mass can be felt in the middle of the side of the buttock. There the tensor is met by the large muscle of the buttock, the gluteus maximus. That muscle inserts into the great trocanter and into a long tendonous strip called the ilio-tibial band, which runs down the side of the thigh between the vastus lateralis and the hamstrings, to be attached into the side of the top of the tibia **(Figure 10.18)**.

The gluteus maximus originates along the back portion of the iliac crest and the sides of the sacrum. The two glutei maximi swell gradually and press together from each side, creating the cleft between the buttocks. The fibers of these muscles are diagonal, the superficial ones going to the ilio-tibial band, the deeper ones to the great trocanter. In the space between the tensor

Fig. 10.16. Observe the Diagonal Spiral of the Sartorius

Fig. 10.17. Observe the Rectus Femoris Emerging From Between the Tensor Muscle and the Sartorius

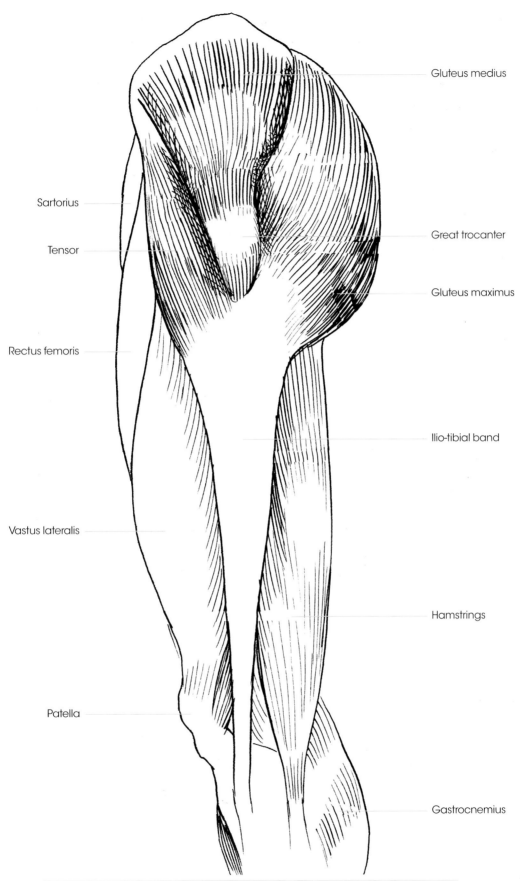

Sartorius

Tensor

Rectus femoris

Vastus lateralis

Patella

Gluteus medius

Great trocanter

Gluteus maximus

Ilio-tibial band

Hamstrings

Gastrocnemius

Fig. 10.18. Muscles of the Thigh, Outer Side

muscle and the gluteus maximus is the gluteus medias (there is also a gluteus minimus but it needn't trouble us). The medias goes from the side section of the iliac crest into the great trocanter. These three muscles that connect the ilium to the great trocanter and, through the ilio-tibial band, to the tibia are responsible for pulling the legs apart. The haunches of the male pelvis are tapered toward each other as they descend to the ischium, while the haunches of the female are more parallel so the pelvis is more open in order to ease childbirth. The effect of this on the gluteus medias is striking **(Figure 10.19)**. The gluteus medias in women has a very significant effect on the shape of the hips, but in men it is less conspicuously nestled between the gluteus maximus and the tensor.

The anatomy of this region centers around the great trocanter, and therefore it is essential to understand where it is in all positions that the body can take, especially in relation to the iliac crest. Stand up with your legs slightly spread, and shift your weight to one side, cocking the pelvis outward. You will find the great trocanter pushing out this side of your body and creating a depression just above it on the opposing side **(Figure 10.20)**—feel this and as much of the iliac crest and the sacrum as you can.

The buttock has come to be regarded as an ignoble part of the body, though in looking at sixteenth-century Italian paintings and drawings, one may be struck by the abundantly developed glutei one sees. I've heard the snickering explanation that these behinds, usually male, are so depicted because the artists or their patrons were homosexual and this body part was of erotic interest to them. And I've also heard the formalist explanation that these artists were concerned with creating volume in their work, and these extremes of rotundity in the rump are simply an experiment in illusionistic relief. Although I see merit in the formal and erotic explanations—and I believe that little of what happens in a good picture comes from a simple solitary motive—I offer another idea: Aristotle, in a humorous mood, said, "Man is the animal with buttocks." I don't suggest that the artists in question knew this quote (although it is quite possible), but as students of the body, they intuited the uniquely human aspect of our semi-spherical glutei. Although all mammals have the muscle that extends from the iliac crest and sacrum to the great trocanter and ilio-tibial band, in quadripedal mammals, the shape and development of this muscle lacks the great development which our bipedal posture requires. Our verticality of stance, which we believe to be a sign of our nobility, is possible largely because of the buttock. When we stand, it serves as a pulley that holds the pelvis, and thus the torso, over the legs. In trying to show the essence of what they depicted, sixteenth-century painters realized that our rumps are an aspect of our essential uniqueness in the animal kingdom and so sought to glorify it.

Female

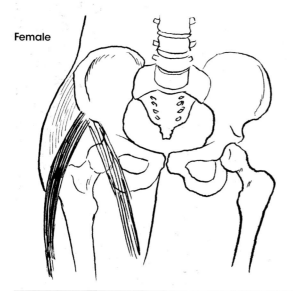

Male

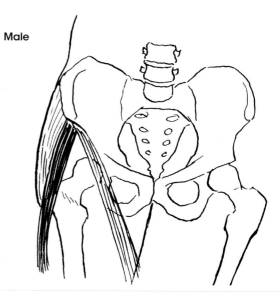

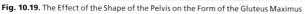

Fig. 10.19. The Effect of the Shape of the Pelvis on the Form of the Gluteus Maximus

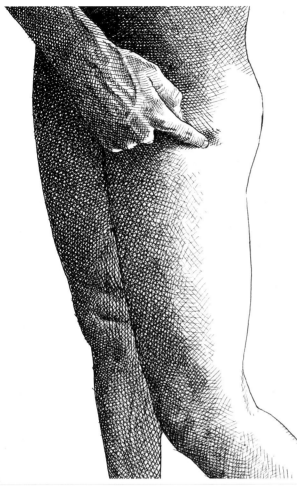

Fig. 10.20. Finding the Great Trocanter

Fig. 10.21. Observe the Tendons of the Insertions of the Hamstrings

With all the muscles in the leg described it is now necessary to find on your own body their insertions near the knee. Begin in a seated position with your leg bent, and feel the curve of the calf muscle as it gently rounds back behind the knee. On either side of this muscle are the tendonous cords that descend from the hamstrings and are inserted in the back of the top of the lower leg **(Figure 10.21)**. Tighten them by trying to bend your leg while preventing it from bending by pushing down on your heel. Move your fingers up to the outer side of the knee and feel the cord-like structure of the tendon there as it inserts at the fibula. As you move around the tendon, you'll find an indentation directly in front of it on the side of the thigh, bordered on the front by the end of the ilio-tibial band **(Figure 10.22)**. This can be felt as a flat tough strip that, depending on your muscular development, is of

Fig. 10.22. Observe the Insertion of the Ilio-Tibial Band

varying clarity. The ilio-tibial band is near the margin of the back of the vastus lateralis.

The quadriceps, as they insert into the patella, can be best explored in a standing position. First stand relaxed and then stiffen your knee joint, making the leg very straight (Figure 10.23); you will see the vastus lateralis and medialis both tighten. The vastus medialis is lower and the more prominent of these two muscles, descending to insert into the inner side of the patella. The vastus lateralis is higher and smoother and has a longer tendon that you can feel as it reaches to the outer side of the patella. Compare the structure of both of these muscles, and note that the vastus medialis is fuller, lower, and toward the front of the leg, while the vastus lateralis is longer and higher, with more mass on the side of the leg. Descending the front of the thigh between these two muscles is the rectus femoralis. With the leg held very straight it should be easy to feel its tendon extending to the top of the patella. Relax your leg and carefully feel how the muscle and tendon soften and lose definition. On the lower side of the patella, find the patellar ligament that connects it to the top of the tibia. Contract and relax the quadriceps and notice the effect it has on the position of the patella, and on the hardness and the form of its ligament. The fullness of the vastus medialis is accentuated by the insertion, just behind it, of the gracilis and the sartorius into the side of the tibia (Figure 10.24).

Now you have made the full circuit around the thigh and you are back at the tendons of the inner hamstrings. Compare the greater prominence of these tendons to the single tendon on the outer hamstring. Be sure to review around the knee with the leg in all positions and in all states of relaxation and contraction.

Now that you are familiar with the structure and function of the individual bones and muscles of the leg, it is necessary to understand them as they work together for their primary purpose—locomotion, in its various forms: walking, running and climbing. Walking is how we usually move around, but we rarely reflect on how we do it (Figure 10.25). Consider a single step and all the muscles that come into play, beginning with the stationary stance. While standing, all of the antagonistic muscles from the pelvis to the feet are in equilibrium; all are slightly contracted and so keep the bones in a balanced and steady relation. To take a step—let us say with the right foot—the right ilio-psoas and the rectus femoris contract, pulling the thigh, and with it the foot, up and forward. Simultaneous to lifting the right foot, the left gluteus medias contracts, which pulls the pelvis to the left, thus keeping the body in balance.

Immediately, the left calf muscles contract, lifting the heel and pushing down the ball of the foot while the left vastus muscles keep the leg straight and rigid. This shifts the weight of the body forward. The right ilio-psoas and rectus femoris contract more, pulling the thigh farther forward and putting more of the body's weight forward. The right tibialis, extensors and peroneus all contract, pulling the toes up at the same time. The left calf continues to contract, now pushing the stride forward through the big toe. The right quadriceps contract, straightening the leg so it can reach forward and down, and then the right heel meets the ground. The right hamstring contracts, pulling the body over the right foot as the left foot now leaves the ground. The left ilio-psoas and rectus contract to pull the leg forward while the leg bends at the knee

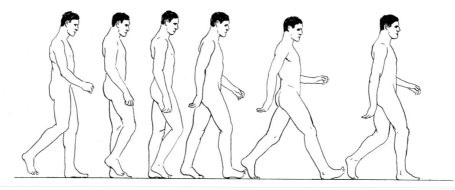

Fig. 10.25. Walking

through a contraction of the gastrocnemius and the hamstrings, thus shortening the length of the leg so it can clear the ground as it swings forward. This forward momentum of the swinging left leg is added to by the contraction of the calf of the right leg, which lifts the heel and pushes the ball of the right foot down. Simultaneously, the right gluteus medias has contracted, tilting the pelvis to the right and keeping the body in balance.

In running and climbing uphill **(Figure 10.26)**, the same sequence of muscular contractions and relaxations is followed, but to a more extreme degree, plus some variations. The muscles of the lower back relax slightly, which tips the torso forward. This shifts the weight of the body forward, which means that the quads of the extending leg contract more to lift the leg higher and farther forward in order to catch the now falling mass of the body. The extended leg, being much farther in front when it strikes the ground than it is in walking, needs the aid of its gluteus maximus as well as its hamstrings to pull the femur back, thus pushing the torso forward over the foot.

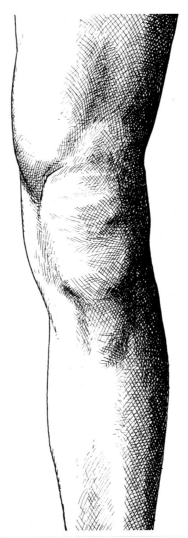

Fig. 10.23. Observe the Movement of the Patella

Fig. 10.24. Observe the Insertion of the Gracilis and Sartorius

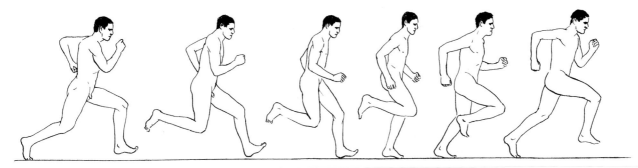

Fig. 10.26. Running

97

The following discussion is the fruit of conversation with Professor Leo Steinberg about Michelangelo's *David*. It is in our discussions that I first understood these two views of the body, as well as the significance of the abdomen in Michelangelo's art.

The Abdomen and the
Muscles of the Erect Posture

The body is an articulated whole designed for motion—how we conceive of this motion, and thus of the whole, depends on how we view the torso.[●] The works of two of the greatest anatomists of Renaissance art—Antonio del Pollaiuolo and Michelangelo—suggest two possible ways of considering the torso. In both the artist allows us to imagine the body as a star, with the head and four limbs as the five points, and the torso as the central pentagon. The difference between these two stellar conceptions of the body lies in the relation between the points and the pentagon. For Pollaiuolo, the head and limbs have priority over the torso. The head, arms and legs extend and move as they will or as external forces direct, and the torso is then positioned as these extremities dictate **(Figure 11.1)**. For Michelangelo, the torso is a dynamo, a source of energy that shoots its power out through the limbs. This is very clearly seen in Michelangelo's drawing of the male abdomen, the complexity of which he explores with greatest penetration **(Figure 11.2)**. Death for Michelangelo, as we see in his great Florentine *Pietà*, is depicted in the laxness of the belly, which extends to the scattered disposition of the limbs **(Figure 11.3)**.

Although other anatomy books begin their description of the body with the torso, their approach has a mechanistic logic unlike Michelangelo's. Other texts follow the order they do out of the logic of going from larger masses to smaller ones, and from the logic of following muscles from their origins to their insertions. Michelangelo's grasp of the body parallels this logic of form and function, but his is fundamentally a poetic notion, based on an effort to spiritualize the entirety of the body by beginning at its central core.

The sublimity of Michelangelo's conception is not an approach I feel to be existentially true. As a living body, I don't feel or think from my torso out. I don't consciously position my trunk and contract its muscles to move my hands. Rather, I move my hands and arms, and the trunk follows. If I were to ask an anatomical novice to contract his deltoid, he'd be at a loss—but if I told him to raise his hand over his head, his deltoid would contract. It is not in conscious muscular movement that the placing of the extremities occurs, but in the placing of the extremities that we discover muscular movement. This is our subjective experience, and I have chosen the limb-first view of the body—found in Pollaiuolo—because of its truth to our subjectivity. In the introduction I said we must re-educate our view of the body in the study of anatomy; since the Pollaiuoloian view is closer to subjective experience and further from the actual logic of movement it might seem like a good thing to abandon. But I want to make it clear that this re-education must be within limits. As I have said, our interest in the body exists because we are bodies; it is this fundamental empathy that motivates the figurative arts. To re-educate ourselves into a purely logical and mechanistic notion that starts with the torso would violate the fundamental motivation behind the figurative arts. The body reduced to a logical machine is interesting but not worthy of love. Is it a surprise that the mechanistic approach to anatomy in the books by George Bridgman and John Hull Grundy were published during the peak of abstraction in art, the moment of art's greatest alienation from the body?

So for us, having explored the active upper and lower limbs, we are left with the remainder—the midriff, the belly, the small of the back, and how these operate together with the rib cage, spine and pelvis. Running down the back, beneath all the muscles of the upper torso we have thus discussed, beginning at the top of the neck and finding attachment to the ribs and all the vertebrae down to the sacrum, are two long cords of muscle—the sacro-spinalis muscles **(Figure 11.4)**. Although these muscles are covered by others, they influence the surface form especially in the lower back where they are covered only by the tendonous sheet of the latissimus dorsi. The

Fig. 11.1. After Antonio del Pollaiuolo's *Hercules and the Hydra*, Uffizi Gallery, Florence

Fig. 11.2. From Michelangelo's *The Last Judgment,* Sistine Chapel

Fig. 11.3. After Michelangelo's Florentine *Pietà*, Cathedral Museum, Florence

sacro-spinalis muscles, in contraction along their course down both sides of the spine, pull the torso back. In strong contraction they can be seen very clearly in the lower back when the trunk is stretched backwards. You should notice how the usually smooth skin of the lower back wrinkles and buckles as these muscles pull the rib cage closer to the buttocks (Figure 11.5).

Antagonistic to the sacro-spinalis is the rectus abdominus—the long flat double column of muscle that extends from the lower front of the rib cage to the pubic arch. Broadly attached to the ribs just beneath the pectorals, the two sides of the rectus abdominus are separated by a vertical line of tendon called the linea alba, or white line. It is so called because unlike the very red muscle that is on either side of it, the linea alba, like all tendonous tissue, is not heavily vascularized and is indeed white. The rectus abdominus narrows gradually as it approaches the pubic arch where it is inserted. The rectus abdominus is notable for its horizontal divisions of tendonous tissue which span out perpendicularly from the linea alba (Figures 11.6 and 11.7). There are usually three of these horizontal bands, usually symmetrically disposed; together with the linea alba, they cut the rectus abdominus into eight lobes. But this division can vary—asymmetry is not rare, and fewer or greater than three bands on one or both sides is also possible. These bands provide tough reinforcement for the rectus abdominus; they divide the strands of the muscle into shorter units, which makes them less likely to rupture and makes it possible for them to contract as independent units.

The sacro-spinalis pulls the rib cage back; the rectus abdominus pulls it forward. Together, in equilibrium, they keep the rib cage vertically placed over the pelvis (Figure 11.8).

On each side of the rib cage, originating between the insertions of the serratus muscles (see page 59), are the diagonally descending external obliques (Figure 11.9). As they approach the sides of the pelvis, the obliques swell considerably, creating the rounded pads of muscle that barely overhang the top of the iliac crests. These flank pads are commonly called the "love handles." If you feel the margin of the iliac crest, you will observe how the obliques form ledges of slightly overhanging muscle (Figure 11.10). As they approach the front of the body on each side of the trunk, the external obliques thin out into tendonous sheets, which split to form a sheath for the vertical bands of the rectus abdominus, and then meet again at the linea alba. An

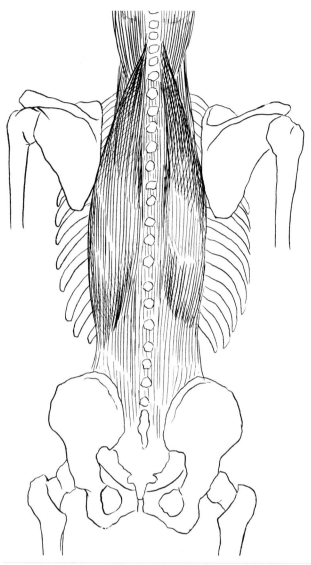

Fig. 11.4. The Muscles of the Sacro-Spinalis

Fig. 11.5. Observe the Effect of Contracting the Sacro-Spinalis

Fig. 11.6. The Rectus Abdominus

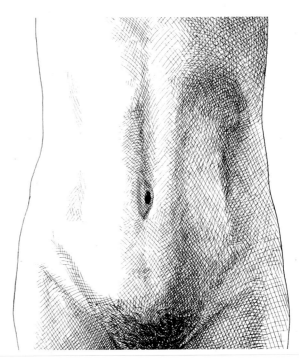

Fig. 11.7. Observe the Rectus Abdominus

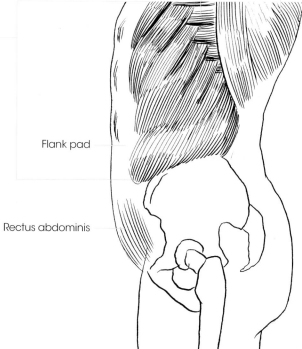

External oblique

Serratus

Latissimus dorsi

Flank pad

Rectus abdominis

Fig. 11.9. The Left External Oblique

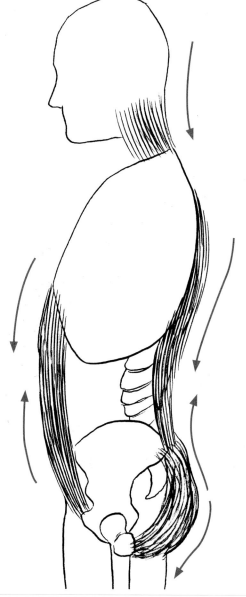

Fig. 11.8. The Muscles of the Back and Belly Working as Antagonists

Fig. 11.10. Observe the Left External Oblique

examination of the cross section of the abdomen makes this clear **(Figure 11.11)**.

When both external obliques contract at the same time, the linea alba and the rectus abdominus are pulled in, which also pulls the pubic arch up slightly. If only one of the external obliques contracts, then the front of the rib cage is rotated away from the contracting side, while the back of the rib cage is pulled toward it **(Figure 11.12)**.

The form of the belly of a thin or well-developed person clearly shows the relation between the external oblique and the rectus abdominus. Note especially the depression between these two muscles where the external oblique becomes a thin sheet of tendon. It is also important to recall the rectus abdominus originates over the surface of the rib cage below the pectorals, where it follows the surface of the ribs before it clearly shows its shape over the belly itself **(Figure 11.13)**.

In considering the erect posture it is essential to think of the body in its entirety. Begin with the feet, which are flat on the ground but supple and arched for strength and shock absorption. The thighs are slightly forward to the lower legs and the two are held one over the other by the antagonism of the quadriceps versus the gastrocnemius and hamstrings. Above these, the glutei maximi pull the pelvis back over the legs while the rectus abdominus, ilio-psoas and rectus femoris pull the pelvis and rib cage forward toward the legs. The sacro-spinalis pulls the vertebrae back in antagonistic relation to the rectus abdominus and external obliques, which pull the torso forward. Our side-to-side stability extends from the buttressing of the malleoli and the antagonism of the peroneus and tibialis through the antagonism of the glu-

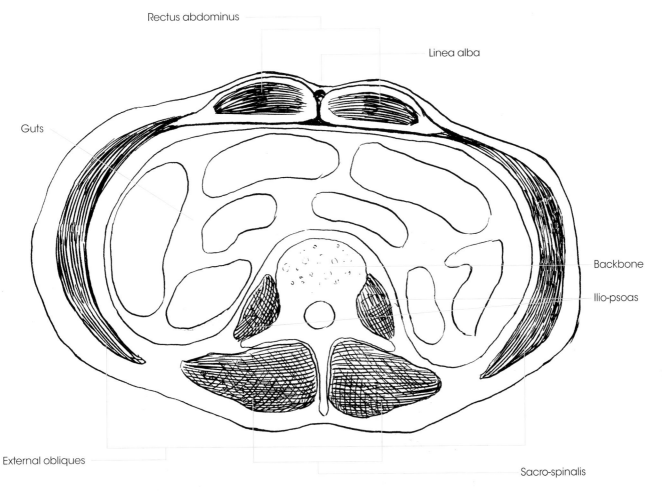

Rectus abdominus

Linea alba

Guts

Backbone

Ilio-psoas

External obliques

Sacro-spinalis

Fig. 11.11. Cross Section Through the Belly

teus medias and ilio-tibial band with the adductors. In the trunk, the symmetry of the right and left sides makes the pairs of glutei medei, external obliques and sacro-spinalis antagonistic to each other. Up the body, side to side, front to back, each set of antagonists provides counteracting forces. Together, the opposing actions pull the body into verticality **(Figure 11.14)**.

Although the erect posture and the bipedal locomotion are structurally more difficult than being on all fours, there were certain advantages for our ancestors: they could see a greater distance over the grasslands they inhabited to look out for predators and game; the female could tend a child in one arm and walk about gathering food with the other; males and childless females could carry arms full of food over a considerable distance back to their family groups; and, finally, our ancestors' versatile hands, inherited from life in trees, were freed for tool making. With the freedom to use our hands, the stage was set more than two million years ago for the development of that feature which makes us the most extraordinary of all creatures—our brains.

Left external oblique contracted **Both relaxed** **Right external oblique contracted**

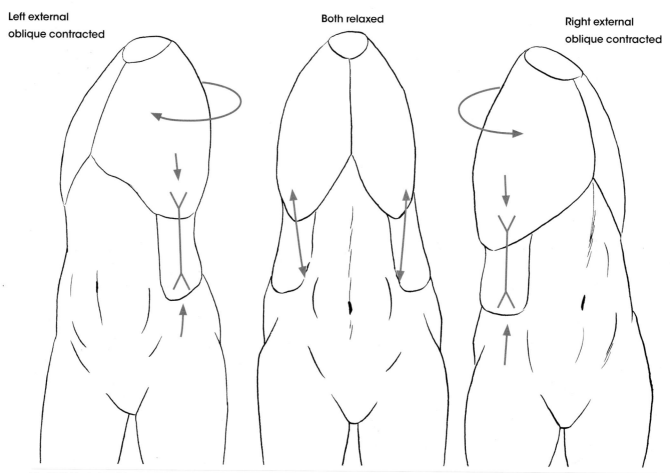

Fig. 11.12. The Action of the External Oblique

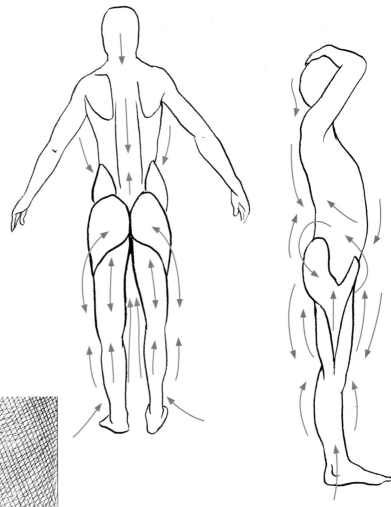

Fig. 11.14. The Counteracting Forces of the Erect Posture

Fig. 11.13. Observe the Ribs Under the Rectus Abdominus

The Head and Neck

We approach the head last, because it came to its present form last in the narrative of our evolutionary development. The seat of our intelligence, the brain, rests within the globular head. The shape of our head, smooth and rounded, rising prominently over the eyes and behind the ears, is unique among animals **(Figure 12.1)**. Its roundness seems an appropriate home for the brain, which comprehends the spherical earth and the vault of the heavens over it. Without our erect posture liberating our hands from use in locomotion, human intelligence would not have been of particularly high survival value. But with hands available for the fashioning of tools and weapons, the smarter we were, the greater our capacity to compete and survive. Today it is easy to forget the necessary relation of hand to brain because of the division of labor in advanced societies. This division means that the hand that performs and the brain that conceives and commands often reside in different individuals: the orders of the general, the boss or the planner are meaningless unless the soldier, the laborer or the builder have the hands to execute those commands, as well as the intelligence to understand them.

One of the earliest developments in the human head—one that came before the phenomenal expansion of brain size and intelligence—was a direct result of the erect posture. This was the migration of the foremen magnum, the hole in the skull that allows the spinal cord to pass into the brain, from the back of the skull to underneath it **(Figure 12.2)**. This allows the skull to balance more easily on the column of the neck. This change occurred early in human evolution, and the image of stoop-shouldered ape-men is certainly inaccurate. The earliest people carried their little ape heads with the same lofty dignity with which we hold up our own **(Figure 12.3)**.

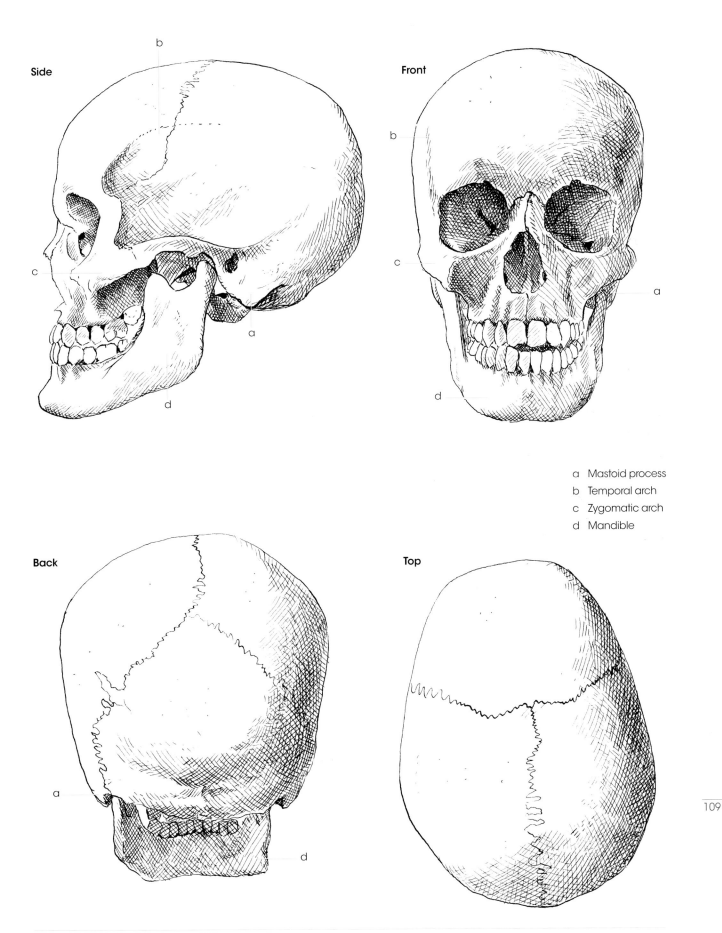

Side

Front

a Mastoid process
b Temporal arch
c Zygomatic arch
d Mandible

Back

Top

Fig. 12.1. The Skull

Primarily responsible for holding our heads up is the nuchal ligament. This ligament is connected to the back of the head and all seven vertebrae of the neck. It functions as a cable that pulls the weight of the head back. Our heads, which are small-faced and have some weight in the back, obviously don't require a nuchal ligament of such strength as heavy-headed quadrupeds like the elephants and rhinos. A ligament serves the function of holding the head up well: it is strong and flexible and, unlike muscle, it does not tire. Like all ligaments and tendons, it doesn't have the power of self-motion. The muscles of the neck are responsible for the positioning of the head, which can tip forward and back and to each side, and turn right and left **(Figure 12.4)**.

The backward tip of the head is accomplished by the trapezius, which is inserted into the base of the skull **(Figure 12.5)**. When the cervical or neck portion of the trapezius contracts, it pulls the back of the head downward. To tip the head forward, since the head is balanced toward the front, all that is usually necessary is for the trapezius to relax and then gravity will pull the face down. But if there is resistance—for example, when we are lying on our backs and we must act against gravity—a pair of muscles come into play: the sterno-clio-mastoid muscles. Each is attached to either side of the head just behind the ear to a bony lump called the mastoid process **(Figure 12.6)**. They then descend the column of the neck to attach to the sternum via a prominent cylindrical tendon and to the

Australopithecus ("Ape-Man")

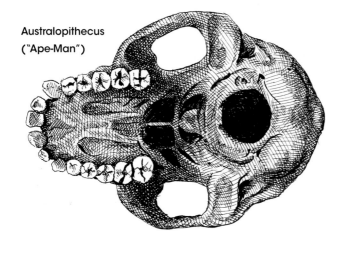

Monkey

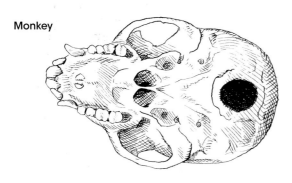

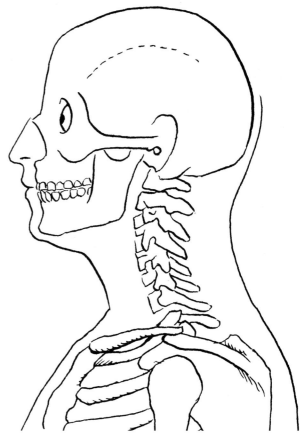

Fig. 12.2. Comparative Locations of the Foremen Magnum

Fig. 12.3. Head on the Shoulders

Fig. 12.4. Positions of the Head

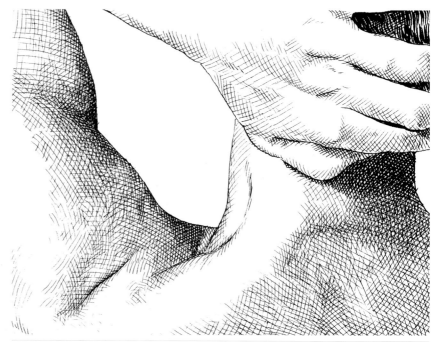

Fig. 12.5 Contracting the Trapezius in the Back of the Neck

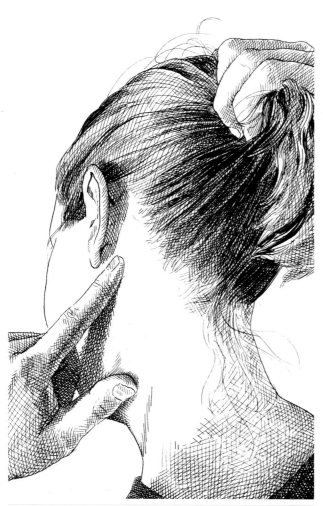

Fig. 12.6 Finding the Mastoid Process

clavicle via a less obvious flat tendon **(Figure 12.7)**. Pulling the chin toward the chest is accomplished through the interaction of both sterno-clio-mastoid muscles. To rotate the head, only one of them contracts, pulling the back of the head toward the contracting side and the chin away from it.

The rotations of the head to the left or the right—possibly the most often performed of the voluntary muscle movements except for blinking and chewing—bear close examination. Looking at yourself in a mirror with your neck and shoulders exposed, turn your head to the left. In doing so, place your fingertips on both sterno-clio-mastoids and feel the muscle bulge as it contracts **(Figure 12.8)**. You will notice in turning to the left, that it is the right side that is contracting, and then, in turning to the right, that it is the left side. This is easy to understand if you realize that the sterno-clio-mastoid is a diagonal muscle that links the front of the chest to the back of the skull—when it contracts the muscle pulls the ear toward the front of the chest. The diagonal sterno-clio-mastoid is thus repositioned to be vertical above the front of the chest. This functional arrangement is reminiscent of the diagonal structure of the external obliques. The twisting of the rib cage over the pelvis is like the turning of the head over the shoulders. In both

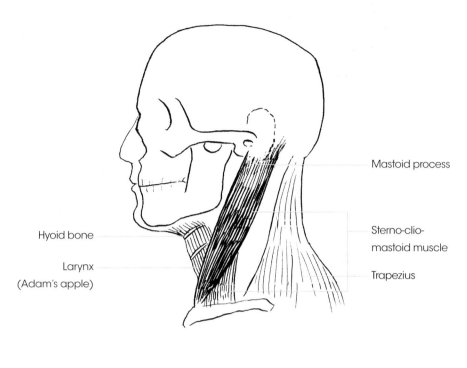

Mastoid process

Hyoid bone

Larynx
(Adam's apple)

Sterno-clio-
mastoid muscle

Trapezius

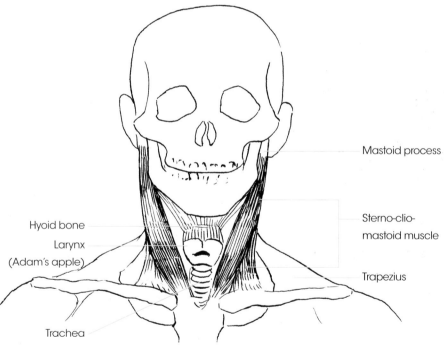

Mastoid process

Hyoid bone

Larynx
(Adam's apple)

Sterno-clio-
mastoid muscle

Trapezius

Trachea

Fig. 12.7. Neck Muscles

113

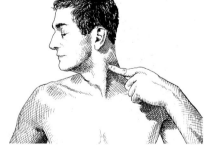

Fig. 12.8. Finding the Sterno-Clio-Mastoid Muscle

cases, to turn left the muscle on the right contracts and vice versa (see page 106).

Between the two sterno-clio-mastoids are the larynx and trachea **(Figure 12.7)** connecting the nose and mouth to the lungs. The larynx protrudes as a sharp pyramidal form against the skin of the neck in men and less so in women. Lower down, the cartilaginous trachea is partially obscured by the presence of the thyroid gland. The larger larynx in men (which causes the deeper pitch of voice), combined with a smaller thyroid gland, makes the male neck less round and more defined than in the female **(Figure 12.9)**. Between the sides of this V, the larynx emerges, slanting forward toward the chin **(Figure 12.10)**. Keeping this slant from being a straight diagonal is the hyoid bone, which is strung under the chin at the top front of the neck and which pulls in the tissues there **(Figure 12.11)**. Starting at your chin, feel downward along the front of your neck to examine these features on yourself. Tipping the head from side to side is performed by one side of the trapezius in the neck acting in conjunction with the sterno-clio-mastoid of the same side.

All of these movements are performed to position the head, which itself should be seen as two units: the face and the braincase. There is an inverse relation in our evolution between the prominence of these two. As the cranium grew larger and rounder, the face shrank. Specifically, the parts of the face that shrank were the jaws and those parts of the skull that provide attachment for the muscles that control the jaw **(Figure 12.12)**. The smallness of the face in relation to the brain is more pronounced in children. The growth of the brain is related to increased dependence on tools and weapons, which made the necessity of powerful ripping, tearing and biting jaws superfluous.

The face of the skull is a bony shield that hangs down from the rounded braincase. It is perforated by several holes that provide receptacles for the sense organs—the connection between the outside world and the brain. The place of each of the organs of the four senses—hearing, sight, taste and smell—has a logic that is obvious, though rarely considered. The mouth is under the nose so that the nose can smell the rising aromas of food before it is ingested. The eyes are near the highest place on the body so that they can see far and that the drippings from the mouth and nose do not cloud them. The eyes of the human and most primates are on the front of the face rather than the side as they are in most mammals. This frontal

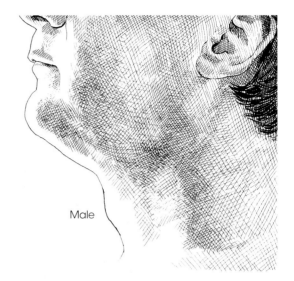

Male

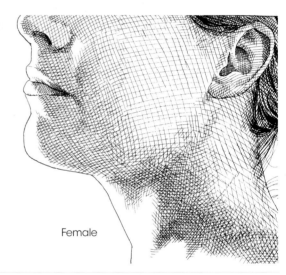

Female

Fig. 12.9. Comparison of Male and Female Adam's Apples

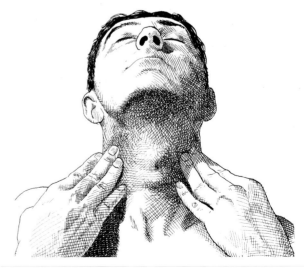

Fig. 12.10. Find the Emergence of the Larynx Between the Sterno-Clio-Mastoids

location permits stereoscopic vision, which allows the mind to sense the things in the world three-dimensionally. The two eyes, spaced a short distance apart, see the world from two different perspectives. The combined information of these two points of view is simultaneously processed by the brain, allowing for the judging of distances. Stereoscopic vision was a necessity for our tree-dwelling ancestors who, in swinging from limb to limb, needed to be able to accurately judge distances. Try to play a game of catch with one eye closed, and you will quickly discover the absolute necessity of stereoscopic vision for judging distances. The even greater distance between the two ears on either side of the head allows us to locate the origin of sounds. One ear, or two ears close together, could provide only a sense of the distance of the origin of a sound by its loudness, but could tell nothing of the direction from which the sound is coming. The outer ear consists of a cartilaginous funnel which directs vibrations in the air into the inner ear, where they are sensed as sound by the brain.

These sense organs, like the windows on the façade of a building, need to be protected. The eyes are set into the skull with prominent ridges of bone above and below them to guard them from impact. The eyelids constantly blink to keep the surface of the eyeball moist and clean; they can shut to protect the eyes from bright light that can

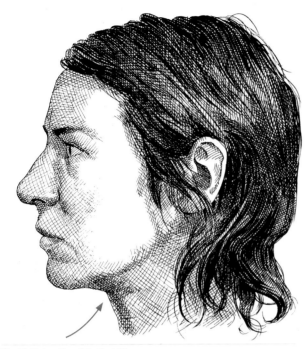

Fig. 12.11. Location of the Hyoid Bone

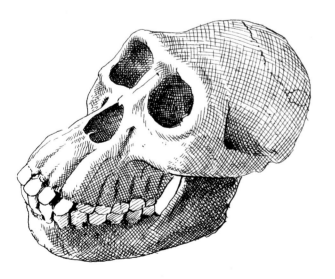

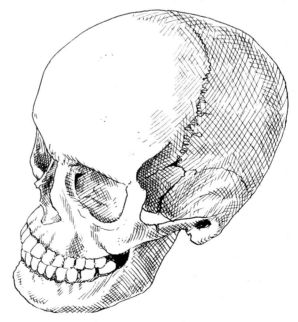

Fig. 12.12. Comparison of Face-to-Brain Ratio in Early Hominid and Modern Human

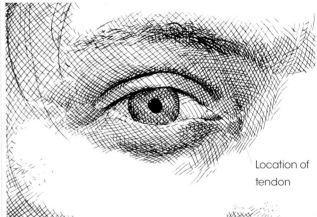

Fig. 12.13. Eye Squeezed Shut and Open

Location of tendon

Fig. 12.14. Lips Puckered

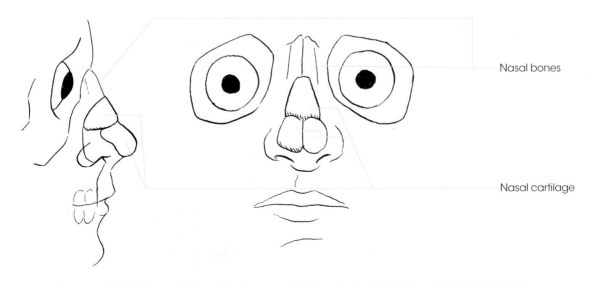

Nasal bones

Nasal cartilage

Fig. 12.15. The Cartilage of the Nose

damage the retina and from particles that can abrade the cornea. The muscle fibers of the eyelid that surround the eye are arranged in a concentric circular configuration. These muscles are tethered to the skull near the nose by a small tendon that you can feel as a small lump on the inner corner of the eye (Figure 12.13). The muscles of the lips are in a thicker but similar circuit of muscles that, when contracted as a whole, cause the lips to pucker (Figure 12.14). These muscles can also be contracted in part. Covering the opening on the skull for the organs of the sense of smell is a "tent" made of three sections of cartilage (Figure 12.15). You can easily feel on your own face where the bone of the root of the nose ends and the cartilage begins by poking up and down along one side of the bridge of your nose: where the finger finds rigidity it is pressing bone; where there is movement under pressure it is cartilage (Figure 12.16). The human nose is unusual in how it juts out from the face—a comparison to our nearest relations shows how unusual it is (Figure

12.17). Some paleo-anthropologists speculate that the prominent nose arose during the ice age as a means of warming up air as it was inhaled; this would prevent the nearby brain from getting excessively cold.

There are many other muscles of the face which are responsible for the rich variety of facial expressions. The placement and action of these muscles can be studied by diligent use of the mirror with special attention paid to the folds and wrinkles formed in extreme facial contortions. Here, as elsewhere in the body, wrinkles tend to be perpendicular to the muscles that form them (Figure 12.18).

The major bony structures in the face are attachments for the most powerful muscles of the head—the muscles for chewing and biting. The delicate ridge of the temple, which is easily felt on the side of the head beside the eye, and which continues as a long graceful arch on the side of the skull (Figure 12.1), is the origin of the temporal muscle. Putting the fingers to the side of your head and grinding your teeth together

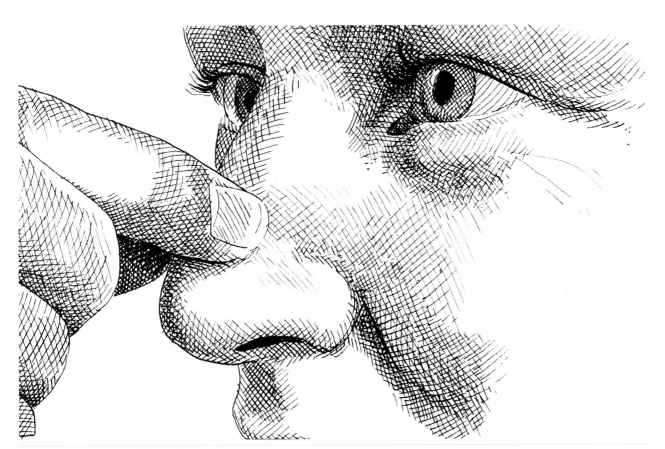

Fig. 12.16. Feeling the Cartilage of the Nose

117

will allow you to feel these muscles swell as they contract **(Figure 12.19)**. The thin fan-shaped temporal muscle points down to the lower jaw, into which it is inserted. This insertion is hidden from sight and touch because it occurs under the arc of bone that extends from beneath the eye to the ear. This is the zygomatic arch, or cheekbone. It is the origin of the most significant facial muscle—the masseter. The masseter is connected to the bottom edge of the zygomatic arch and descends diagonally to be inserted near the corner of the lower jaw. The masseter can also be felt and seen by pressing the jaws together **(Figure 12.20)**. In some people, the front edge of the masseter forms a strong diagonal line from under the eye to the corner of the jaw. This is especially present in thin individuals and becomes most pronounced when the cheeks become sunken during and after strenuous bodily exertion. This line can be easily found on your face first by feeling for it, and then by looking in the mirror while sucking the cheeks in **(Figure 12.21)**. Once you know the presence of the front edge of the masseter is there, you can discern it in even the most full-cheeked subject. For the draftsman, the distance between the eye and the ear can sometimes seem like the greatest distance in the body—an empty zone with little contour. An understanding of the zygomatic arch and the masseter provides landmarks for the artist's eye in traversing this distance.

In our evolutionary development, intelligence combined with social existence made articulate speech a possible advantage, but in apes, even with the reduction in size of the lower jaw, a bony shelf that reinforced the U-shape of this structure still made clear speech difficult. The solution to this was the displacement of this buttress of bone into a knob of bone in front of the jaw—the chin **(Figure 12.22)**. This was a very late arrival in our skeletal structure and we must imagine our pre-Cro-Magnon ancestors as folk of few words.

* * *

I wanted in this book to give an account of the human body that is rooted in the origin and function of the features of the body and to make it memorable because reading it requires an examination of your own body. Our journey through the body has been through space, moving systematically with our eyes and hands through the major structures. It has also been a journey through time as we followed the evolutionary unfolding of hands, feet and head. This temporal journey may be less than acceptable to some readers, but even they, I believe, will see the logic of this unfolding, even if they question its truth.

You now have a framework from which your anatomic knowledge can grow. There are levels of refinement that we have not touched, aspects of movement that were beyond our scope. With what you have acquired here, you begin a lifetime of ever-deeper understanding and perception and knowledge of the human body.

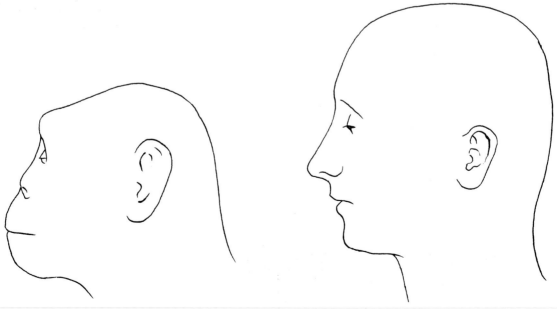

Fig. 12.17. Comparison of Ape and Human Noses

Fig. 12.18. Forehead Wrinkles Are Perpendicular to the Contraction of the Muscles

Fig. 12.19. Feel the Temporal Muscle

Masseter

Fig. 12.20. Contracting the Masseter Clenches the Jaw

Masseter

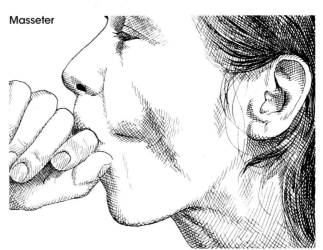

Fig. 12.21. Sucking In the Cheeks Emphasizes the Masseter

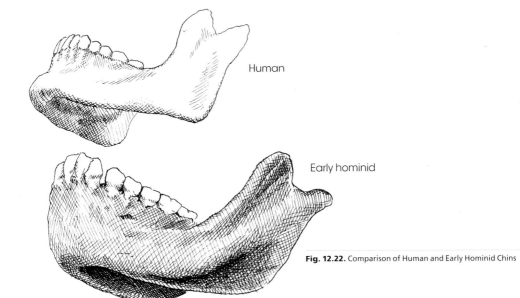

Human

Early hominid

Fig. 12.22. Comparison of Human and Early Hominid Chins

On Beauty

It is clear that the study of anatomy yields a better understanding of the three-dimensional volumes of the body, but a word about anatomy and its influence on the two-dimensional silhouettes of living forms may be useful. A common expression of praise for a drawing is to talk about the "beauty of line." What does this mean? What is the nature of a beautiful line? The eighteenth-century British painter William Hogarth believed he discovered the answer and described it in a treatise called *An Analysis of Beauty*. Hogarth's line is basically a long S curve; one significant thing about this line is that it does not repeat itself—every bend of the curve is at slight variance to every other bend in the curve. The other significant aspect of Hogarth's line is that these variations are slight so the line has unity as well as variety **(Figure A.1)**. Variety bound to unity is the classical definition of beauty—so it seems that Hogarth may have been on to something with his line. To explore the idea of unity and variety in the body, let us examine some of the repeated patterns of structure we have seen in the preceding pages.

In the ankles, neck and belly, all places of significant movement, there are structures that cause these parts of the body to follow what we might call the Law of Conservation of Volume, or Compactness. Tendons and muscles, being cords, seek to be straight lines when put under tension, as they are during muscular contraction. Recall the tibialis (page 73) with its origin near the knee and its insertion on the metatarsal of the big toe, and imagine that muscle contracting as a cord under tension does, becoming a straight line between its two ends. What painful strain it would put on the skin over it, and how it would pull against the muscles surrounding it. To prevent this, the annular ligament, thin and very tough, wraps around the bones and tendons of the ankle, thus keeping the tendon of the tibialis and of the other muscles in their place. Similarly, recall the rectus abdominus in the belly (page 102), with its transverse tendons that divide it into lobes; recall its origin in the rib cage and its insertion in the pubic arch of the pelvis. Now imagine it without these dividing tendons, and imagine it contracting. Again, it is a cord under tension seeking to be a straight line, and again, it is straining against the skin and disrupting the organs that it covers. Now imagine the organs of the neck without the hyoid bone stringing them tightly under the chin (page 113-114). Without that restraint, the weight of the tongue and larynx would press against the skin, and they would be pulled out of proper functional relation with each other. These are all places where structures exist for the same function, that of maintaining compactness. In each of these cases the structures are

Fig. A.1. Hogarth's Line of Beauty

of different tissue: ligament, tendon or bone, but in each case they follow similar forms: they are perpendicular to the tension that they are restraining and they embrace the tissues beneath them.

In other places in the body we have seen nearly identical structures occurring in different places, for example, hinge joints in the phalanges, wrist, elbow, neck and knee; ball-and-socket joints connecting the phalanges to the metacarpals, the humerus to the scapula, and the femur to the pelvis. The hinge joints are always in the length of an appendage, and the ball and socket join to a larger mass. This we could call the Law of Conservation of Invention. We see this law at work in the recurrence of the basic patterns of ligament, bone, muscle and tendon throughout the body. The circular arrangements of muscle fibers around the eye and mouth have been noted; it is the same kind of structure, a sphincter muscle, which closes the anus. To recognize the eyelids and lips as modifications of the form of the anus does not debase these features of the face, but instead should make us marvel at the economy of invention found throughout the body.

We are always aware of our bilateral symmetry, the fact that the right side of the body is a mirror image of the left. But consider the symmetry between the top and bottom halves of our bodies. The shoulder girdle and arms reflect the pelvis and legs, and the lips and mouth reflect the other end of the alimentary canal, the anus and the rectum. The vertical and horizontal symmetries of the body show the law of conservation of invention as the major organizing principle of our entire bodily form.

The conservation of volume and the conservation of invention create rhythms throughout the body's design that are like theme and variation in music. Through the basic themes of structure and function we have unity; through their permutations we have variety. This takes us back to the classical definition of beauty. Certainly without unifying themes there is chaos, which is ultimately uninteresting, and without variety there is certainly boredom. But is this interestingness beauty? One example is enough to answer the question with a clear "No": the cockroach. Here is verily as much unity and variety as in the most beautiful human body, and, although the roach may be interesting in form, it is not attractive (to us; cockroaches themselves have a different view). So unity and variety create interest, but it is not enough; to call a thing beautiful we must be attracted, we must desire it. So the classical definition of beauty describes a necessary but not sufficient cause of beauty.

So why is the beautiful, beautiful? Or to say it in a way that sounds less tautological, why are we attracted to some things more than to others?

I believe the answer lies in natural selection and evolution. We don't wonder why we crave sweet and salty flavors, or why we crave foods high in fat. The answer is simple: such foods are essential for survival and, for pre-agricultural people, are difficult to get. Fruits with their sweetness are seasonal; salt is scarce; and animals with fatty flesh have to be hunted. When these food sources are available, we are biologically programmed to gorge on them, because our body believes that it will be a long while before they are likely to be available again. In agricultural and industrial societies, this programming backfires: we are designed to gorge on foods that are no longer scarce, and obesity is the inevitable result if willpower is not exercised.

Physical beauty has a similar basis in survival as do pleasant tastes; just as tastes satisfy our instinct for nourishment, physical beauty satisfies our instinct for successful procreation. The love of beauty is not, as some would have it, a myth, but is a very real instinct built into the core of our being—our genes. Of course, there are cultural determinants for the specifics of physical beauty, but there are more important universals that exist in all cultures. These universals are consistent with bodily health and fertility. No animal species will survive long if individuals of that species do not consistently choose mates that look healthy and fertile, or, to put it differently, who do not choose mates that are beautiful.

If signs of health and fertility are the source of beauty, then fullness of hip and breast in women and symmetry and strength of body in both sexes are universally attractive. This much is obvious. To be a little more subtle, fitness of the body is revealed in a very particular play of the body's forms, characterized by several qualities: a fullness of volume which is caused by an internal pressure pushed out against the surface of the skin; smoothness and clarity of the surface; the appearance of solidity and firmness combined with a sense of softness; complexity of form in varying rhythmic patterns; symmetry of the body as whole but with the body in complex motion or posture so that the symmetry is dynamic and not static. All of these qualities together reveal a human body with vigor and energy. (The last two, without the others, are qualities of all healthy animals, even the cockroach.) Absent from a healthy human body are the opposites of these qualities: concavity of volume or volume

that does not have sufficient pressure and therefore sags from the pull of gravity; raggedness and variegated surface; the appearance of flabbiness or bony hardness; lack of rhythm in the patterning of forms or lack of complexity in the patterning; asymmetry; lack of movement; and stiffness of posture.

If these formal qualities of the healthy body are examined in terms of the kind of outline that describes them, the result is a line similar to Hogarth's: a smooth, sinuous, voluptuous line of variety and unity. Look at the outline of Botticelli's Venus, or the silhouette of any figure by Raphael **(Figures A.2 and A.3)**, and the signs of health in these bodies will reveal themselves as precisely coincident with these qualities. One aspect of a beautiful body must be stressed: the convexity of line. In tracing the outline of a healthy body, hardly a concave line will be found—those that appear to be concave are really a series of interlocking convex lines, sometimes subtly convex, but convex just the same. This convexity should be no surprise if you remember that strong muscles are always full and rounded. The complex interlocking of these rounded muscular forms are what give the healthy body its characteristic appearance, which we call beautiful. Excess of fat disguises the rhythmic complexity of the interweaving of the muscles. Extreme emaciation atrophies the muscles into concavity, revealing the largeness of the bones at the joints. Artists in the past knew this, and often exaggerated the overlapping and fullness of the muscles in order to show the vigor and vitality of the bodies they were depicting **(Figure A.4)**. To do this effectively, a knowledge of anatomy was indispensable; anatomical knowledge is important for accuracy, but essential for convincing idealizations of the body.

When you follow the outline of a great figure drawing, every movement of the line reflects the artist's knowledge of anatomy. The angular lines of an expressionist like Egon Schiele are exaggerations of the truth; the seemingly monstrous distortions of Picasso are always deeply rooted in the same truth. Indeed, in figure drawing, truth is beauty and beauty, truth.

We are genetically programmed to admire and seek beauty in the human body, and this drive is so strong that is spills out into all that we see and create. The qualities of beauty in landscapes, architecture, clothing, and graphic and industrial design are all deeply if unconsciously based on the beauty of the healthy body and its special qualities of proportion, dynamism and strength. In seeking originality, the artist or designer can deliberately leave these qualities behind, but in so doing, beauty will also be abandoned.

Fig. A.2. After Botticelli's Venus (Uffizi Gallery, Florence)

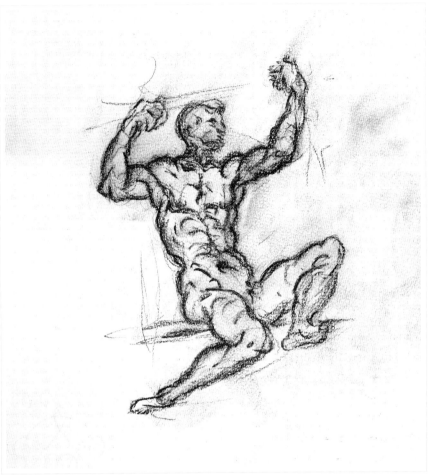

Fig. A.4. After a Tintoretto drawing in the Uffizi Gallery, Florence, by Anthony Apesos

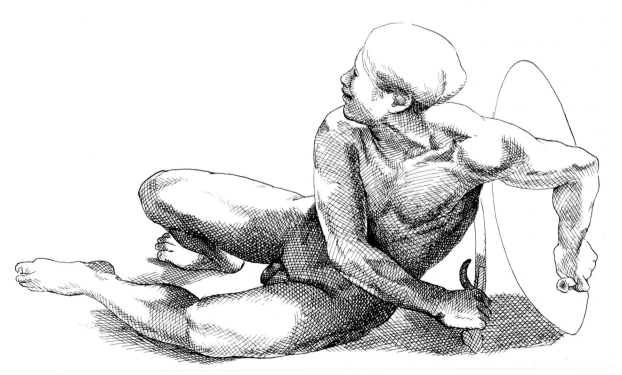

123

Fig. A.3. After a Raphael drawing in Ashmolean Museum, Oxford

Bibliography

To continue your anatomical studies, there are a number of useful books available. Many of the books below are commonly found in good bookstores, and all of them are currently in print. No one book is sufficient because no one book has the combination of clear text, beautiful drawings and photographs, and thoroughness that the student really needs.

An Essential Anatomical Library

Eliot Goldfinger, *Human Anatomy for Artists* (New York: Oxford University Press, 1991). This is far and away the best and most complete book on artistic anatomy. It combines clear diagrams, excellent photographs, a fine text, and intelligent and clear organization. It is perfect as a reference, though much too complete for the beginner; but if you've read this book carefully, you are no longer a beginner. My only real complaint about Goldfinger's book is the drawings—they are useful but they aren't very attractive. Add to your library a few books which show how stunningly beautiful anatomical illustrations can be as a supplement to Goldfinger.

Every artist should own *Illustrations from the Works of Andreas Vesalius of Brussels* (New York: Bonanza Books: Distributed by Crown, 1982). Vesalius was a sixteenth-century physician who published the first accurate anatomical drawings. What is especially wonderful is not just their fidelity, but because the woodcut plates were designed and engraved in the studio of Titian, they are remarkable works of art, full of energy, volume, and a strangely grotesque sense of humor.

After Vesalius the greatest set of anatomical illustrations are by the eighteenth-century Dutch physician Bernard Siegfried Albinus, and are available in Robert Beverly Hale and Terence Coyle's *Albinus on Anatomy* (New York: Watson-Guptill Publications, 1979). These plates are wonders of accuracy and clarity and the dissected figures shown in them appear in wonderfully imagined landscapes, including one with a rhinoceros.

Michael Burban's *Lessons from Michelangelo* (New York: Watson-Guptill Publications, 1986) uses Michelangelo's drawings (and those of his followers, a fact of which Burban seems unaware) and his own diagrams to give some useful anatomy lessons. Especially valuable are many of the poses found in the drawings and Burban's explanation of them.

I don't believe you'll ever fully grasp anatomical structure just by looking at pictures. A good text with clear explanations can clarify the best of drawings. I recommend for this Arthur Thomson's *A Handbook of Anatomy for Art Students* (New York: Dover Publications, 1964, first published by Oxford University Press, 1896). It has the advantages of being easy to find and having a clear, elegant and thorough text. If you want further detail of text, the 1977 reprint of *Gray's Anatomy* (New York: Bounty Books: Distributed by Crown, [1987], 1977) is unsurpassed. The plates are also useful, especially those of the bones, which show the origins and insertions.

Sometimes a look at real flesh and bones makes an anatomical structure suddenly become clear in the mind. R.M. McMinn and R.T. Hutchings's *A Color Atlas of Human Anatomy* (Chicago: Year Book Medical Publishers, 1985) is full of photographs of actual dissections.

At some point you are bound to come across the books by George Bridgman. All seven of his books are combined in *Complete Guide to Drawing From Life* (New York: Sterling Publishing, 1952). His drawing style is clearly of his time, the 1920s and 1930s, filled with Art Deco exaggerations and simplifications, but in spite of this, or perhaps because of it, they can be very useful. The section of this book that I especially recommend is *Constructive Anatomy*, also available as a separate book (New York: Dover Publications, [1937], 1920), which demonstrates the origin and insertion of muscles with unparalleled clarity.

Glossary

Antagonist
A muscle that pulls in opposition to another muscle.
Example: The biceps is an antagonist to the triceps.

Arboreal
Tree living, adapted to life in trees.

Articular surface
The part of a bone that joins to another bone.

Articulation
The joining of bone to bone.

Ball-and-socket joint
A joint where a convex articular surface of one bone fits into the concave articular surface of another, allowing for a wide range of motion.
Example: The hip joint.

Biped
An animal that walks on two legs.

Bipedal
Possessing the ability to walk on two legs.

Bone
Any part of the skeleton that is hard tissue composed mostly of calcium.

Brachiation
The ability to swing by the arms as a means of locomotion.

Cartilage
A firm, elastic tissue that occurs as a cushion between bones on their articular surfaces, and can serve a structural function in other parts of the body, such as the ear.

Collagen
A protein that occurs in long molecular strands and is found in connective tissues. It is a primary component of cartilage, tendon and ligament.

Connective tissue
The tissue that connects or supports the parts of the body.
Example: Bone, ligament, tendon and muscle sheath.

Contraction
The shortening of a muscle that moves one bone in relation to another.

Distal
Situated away from the core of the body.
Example: The fingers are distal in comparison to the elbow. The opposite of proximal.

Extend
To straighten. The opposite of flex.

Fat
A soft tissue that serves as a cushion in some parts of the body, but whose primary purpose is the storage of energy.

Fixed joint
A place of articulation of bones where movement is impossible.
Example: The joints that connect the parts of the cranium.

Flex
To bend. The opposite of extend.

Hinge joint
A simple joint in which bones are arranged so that they can only extend or flex.
Example: The elbow.

Insertion
The distal attachment of a muscle to bone. The opposite of origin.

Joint
A place where two or more bones are connected together.

Landmark
A part of the body that is a visible and obvious reference point, used in studying anatomy. Most often used for the subcutaneous bones.

Ligament
The connective tissue that attaches bone to bone.

Muscle
The tissue that is capable of contraction, thus providing the source for almost all movement in the body. Muscle is highly vascularized, and thus red.

Muscle sheath
The very thin layer of connective tissue that tightly surrounds each muscle and some groups of muscles and helps them to hold their form.

Opposable
Used here in reference to the thumb's capacity to touch each of the other fingers.

Origin
The proximal attachment of muscle to bone. The opposite of insertion.

Process
Any bony protuberance, often the place of origin or insertion of muscle.

Pronate
To turn the palm out or upward.

Proximal
Situated near the core of the body, as the elbow is proximal in comparison to the finger. The opposite of distal.

Spine
A bony process, especially one that protrudes further in distance than the width of its base.

Subcutaneous
Immediately beneath the skin, with no other fat or muscle present, especially the subcutaneous bones.

Supinate
To turn the palm in or downward.

Tendon
The connective tissue that attaches muscle to bone.

Tissue
Any grouping of similar cells that function together. Those that are especially relevant for artistic anatomy are bone, muscle, cartilage, tendon, ligament and fat.

Index

The best in fine art instruction and inspiration is from North Light Books!

Keys to Drawing with Imagination
by Bert Dodson
ISBN-13: 978-1-58180-757-8
ISBN-10: 1-58180-757-0
Hardcover with concealed spiral, 192 pages, #33424

Discover new ways of working that free your creativity! Every artist wants to be more creative, and this book demystifies that often confusing process. There are over forty exercises to help you unlock the power of the imagination and learn how to recycle old drawings into fresh ideas. With fun exercises, expert instruction and a gallery of inspiring examples, artists of all levels will come away more confident and creative!

Drawing and Painting People: The Essential Guide
edited by Jeff Blocksidge and Mary Burzlaff
ISBN-13: 978-1-58180-981-7
ISBN-10: 1-58180-981-6
Paperback, 192 pages, #Z0817

Eight professional artists share proven techniques and time-tested advice for painting everyone's favorite subject—people. Favorite color mixes, tips on lighting your subject, strategies for creative cropping, advice for getting the eyes "just right"— it's all here, along with other valuable lessons and expert know-how to make the people in your artwork expressive, engaging and "real."

Drawing People: How to Portray the Clothed Figure
by Barbara Bradley
ISBN-13: 978-1-58180-359-4
ISBN-10: 1-58180-359-1
Hardcover, 176 pages, #32327

Drawing People provides a complete course on drawing the clothed figure from an award-winning illustrator and drawing instructor. In addition to basic drawing topics such as proportion, perspective and value, Barbara Bradley explains how clothing folds and drapes on figures both at rest and in motion, and gives special tips for drawing heads, hands and children.

These books and other fine North Light titles are available at your local fine art retailer or bookstore or from online suppliers.